BERNARD PALISSY

☞ Books in the RENAISSANCE LIVES series explore and illustrate the life histories and achievements of significant artists, rulers, intellectuals and scientists in the early modern world. They delve into literature, philosophy, the history of art, science and natural history and cover narratives of exploration, statecraft and technology.

Series Editor: François Quiviger

Already published
Albrecht Dürer: Art and Autobiography *David Ekserdjian*
Aldus Manutius: The Invention of the Publisher *Oren Margolis*
Andreas Vesalius: Anatomy and the World of Books *Sashiko Kusukawa*
Artemisia Gentileschi and Feminism in Early Modern Europe *Mary D. Garrard*
Benvenuto Cellini and the Embodiment of the Modern Artist *Andreas Beyer*
Bernard Palissy and the Arts of the Earth *François Quiviger*
Blaise Pascal: Miracles and Reason *Mary Ann Caws*
Botticelli: Artist and Designer *Ana Debenedetti*
Caravaggio and the Creation of Modernity *Troy Thomas*
Descartes: The Renewal of Philosophy *Steven Nadler*
Domenico Ghirlandaio: An Elite Artisan and His World *Jean K. Cadogan*
Donatello and the Dawn of Renaissance Art *A. Victor Coonin*
Erasmus of Rotterdam: The Spirit of a Scholar *William Barker*
Filippino Lippi: An Abundance of Invention *Jonathan K. Nelson*
Francis I: The Knight-King *Glenn Richardson*
Giorgione's Ambiguity *Tom Nichols*
Hans Holbein: The Artist in a Changing World *Jeanne Nuechterlein*
Hans Memling and the Merchants *Mitzi Kirkland-Ives*
Hieronymus Bosch: Visions and Nightmares *Nils Büttner*
Isaac Newton and Natural Philosophy *Niccolò Guicciardini*
Jan van Eyck within His Art *Alfred Acres*
John Donne: In the Shadow of Religion *Andrew Hadfield*
John Evelyn: A Life of Domesticity *John Dixon Hunt*
Leon Battista Alberti: The Chameleon's Eye *Caspar Pearson*
Leonardo da Vinci: Self, Art and Nature *François Quiviger*
Lucas Cranach: From German Myth to Reformation *Jennifer Nelson*
Machiavelli: From Radical to Reactionary *Robert Black*
Michelangelo and the Viewer in His Time *Bernadine Barnes*
Paracelsus: An Alchemical Life *Bruce T. Moran*
Petrarch: Everywhere a Wanderer *Christopher S. Celenza*
Piero della Francesca and the Invention of the Artist *Machtelt Brüggen Israëls*
Piero di Cosimo: Eccentricity and Delight *Sarah Blake McHam*
Pieter Bruegel and the Idea of Human Nature *Elizabeth Alice Honig*
Raphael and the Antique *Claudia La Malfa*
Rembrandt's Holland *Larry Silver*
Robert Hooke's Experimental Philosophy *Felicity Henderson*
Rubens's Spirit: From Ingenuity to Genius *Alexander Marr*
Rudolf II: The Life and Legend of the Mad Emperor *Thomas DaCosta Kaufmann*
Salvator Rosa: Paint and Performance *Helen Langdon*
Thomas Nashe and Late Elizabethan Writing *Andrew Hadfield*
Titian's Touch: Art, Magic and Philosophy *Maria H. Loh*
Tycho Brahe and the Measure of the Heavens *John Robert Christianson*
Ulisse Aldrovandi: Naturalist and Collector *Peter Mason*

BERNARD PALISSY

and the Arts of the Earth

FRANÇOIS QUIVIGER

REAKTION BOOKS

Published by Reaktion Books Ltd
2–4 Sebastian Street
London EC1V 0HE, UK
www.reaktionbooks.co.uk

First published 2025

EU GPSR Authorised Representative
Logos Europe, 9 rue Nicolas Poussin, 17000, La Rochelle, France
email: contact@logoseurope.eu

Printed and bound in India by Replika Press Pvt. Ltd

A catalogue record for this book is available from the British Library

ISBN 978 1 83639 084 8

COVER: Bernard Palissy, rustic basin, *c.* 1550–60, glazed earthenware.
Musée des Beaux-Arts de Lyon (Inv. H 475), image © Lyon MBA –
Photo Alain Basset.

CONTENTS

Introduction 7

1 Life and Strife 12

2 Works 55

3 Reception 89

4 The Sentient World of Bernard Palissy 107

5 Afterlives 133

Conclusion 143

CHRONOLOGY 149

REFERENCES 151

SELECT BIBLIOGRAPHY 171

ACKNOWLEDGEMENTS 177

PHOTO ACKNOWLEDGEMENTS 179

INDEX 181

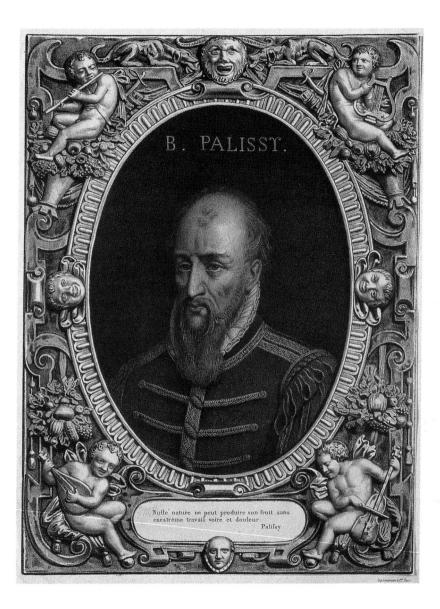

B. PALISSY.

Nulle nature ne peut produire son fruit sans
exestrême travail voire et douleur
Palissy

Imp.Lemercier &C.ie,Paris.

Introduction

ernard Palissy was an artisan philosopher who discerned sensation, consciousness and intelligence in soils, minerals, plants and animals. He considered agriculture his core discipline and named his own profession of ceramist 'the art of the earth'. In fact, he practised the arts of the earth, producing not only ceramic ware but fountains, grottoes and gardens. From his understanding of matter as an intelligent, active and reactive substance, he produced multisensory objects and installations for the entertainment of courtly elites. In parallel his knowledge expanded into an eclectic, and sometimes dissident, philosophy of nature. He did not share the Renaissance enthusiasm for humans as marvels of nature. Instead, he contrasted human weakness and foolishness with animal robustness and wisdom and ignored early modern assumptions on human superiority, anticipating twenty-first-century environmental preoccupations and understanding of non-human intelligence.

Palissy's life is one of swelling ambition; he moved on from terracotta plaquettes, plates, bowls and rustic basins to grotto installations, fountains, gardens and even fortifications. Born in 1510, he achieved financial success and fame from the mid-1550s thanks to a new genre of ceramics with casts of animals and plants, his so-called *figulines*, which secured him royal patronage (illus. 1). Unlike most artisans of his time, he also lectured and

1 Bernard Palissy, from Carle Delange, *Monographie de l'œuvre de Bernard Palissy . . .* (Paris, 1862).

published. He produced three texts: a brief dialogue describing his first artificial grotto, the *Architecture et ordonnance de la grotte rustique* (1563), and two substantial books, the *Recepte véritable* of 1563–4 and the *Discours admirables* of 1580, based on public lectures delivered in Paris in 1575.

A large number of enamelled plates and rustic basins previously attributed to him have been recently redated to the beginning of the seventeenth century, thus confirming the expansion of the genre he contributed to establish, even though his own name was falling into oblivion at the time. Rediscovered in the late eighteenth century, and praised for his insight in matters of geology, palaeontology and agriculture, Palissy rose to unprecedented national fame in nineteenth-century France. The autobiographical tale, told to generations of French school children, according to which he allegedly broke and burnt his house furniture to keep his kiln at the correct temperature, raised his status from inexperienced and obstinate experimenter to national hero celebrated in texts and images (illus. 7, for example). Romantic heroizations of Palissy inspired reinvention of what was then thought to be his style. An entire school of ceramists, the so-called French Palissystes, was born out of the desire to imitate and emulate Palissy's nineteenth-century avatar.[1] This intense afterlife secured his celebrity in France where streets, public squares, schools and colleges are named after him; it also prompted archival research with the outcome that the Palissy we know today is a much more obscure figure (due to much information about him being proven to be unfounded) than was his Romantic reincarnation.

Documents published over the years by the *Bulletin de la Société de l'Histoire du Protestantisme Français* have clarified his significant involvement in the Reformation, and confirmed his sad and brutal death in 1590 in the Bastille jail where he was incarcerated for his religion. Excavations have shed new light on Palissy's Parisian workshop. The first campaign goes back to 1878 when sixty

2 Bernard Palissy, fragments.

fragments promptly associated with him were unearthed from a trench dug in the Carousel Garden of the Tuileries Palace.[2] Between 1984 and 1990 further excavations in the Tuileries gardens uncovered the kilns that were probably used to fire components of the Medici grotto as well as a corpus of around 8,000 fragments now kept and currently catalogued at the Musée National de la Renaissance in Écouen, north of Paris (illus. 2).

The past forty years of Palissy scholarship have produced two critical editions and numerous digital editions of related sources, studies and research papers. As one of the few sixteenth-century craftsmen to have published and entered the public debate, Palissy now stands out as an important actor in the recent re-evaluation of the contribution of artisan culture to the history of knowledge.[3] Two collective volumes published on the centenary of his death, in 1990, have been followed by campaigns of scientific examination with the tools of modern conservation, resulting in a drastic reduction of his catalogue to – so far – only ten authenticated pieces and many fragments awaiting further scrutiny.[4]

Palissy is sometimes compared to Leonardo da Vinci. Both were self-taught natural philosophers; they acquired their knowledge through conversations, experience and vernacular translations; and they both served the Medici dynasty. Leonardo designed and orchestrated the marriage celebrations of Madeleine de la Tour d'Auvergne and Lorenzo de' Medici. Their daughter, Catherine de' Medici was to become Palissy's main patron.

The extravagant celebrations associated with the Medici dynasty had, since the fifteenth century, set the tone for the splendour of Renaissance festive culture. Leonardo contributed with theatrical machines, costumes and orchestrated re-enactments of French military victories. Palissy's contribution focused exclusively on the natural world. His rustic ceramics and grotto installations – attractions of princely gardens intended to delight and impress

important visitors – represented the natural world in the intensely scripted universe of Renaissance court entertainments. His thought, however, substantially differs from that of his patrons and their courtly culture.

With only ten authenticated pieces, one booklet and two texts, the scant and scattered remains of Palissy's work are the tip of a dissolved iceberg, insufficient to trace the development of his style through the chronology of his life. Advances in research have shown how little we really know, yet there is enough for the five chapters of this book to examine Palissy from the perspectives of his own philosophical and religious beliefs, those of his patrons and his imitators.

The first chapter follows Palissy chronologically, from his beginnings, struggles and successes to his brutal death in jail, with particular attention to the circumstances that affected his life and the individuals that made his career possible. The second chapter surveys the surviving works and grotto projects; the third examines the reception and use of Palissy's productions by his principal protectors, Anne de Montmorency and Catherine de' Medici. Approaching Palissy from this angle highlights a large gap between the contemporary perception of his ceramics and his own philosophy of art and nature – the subject of the fourth chapter. Monographs on Bernard Palissy generally conclude with his nineteenth-century followers, yet some of his views vividly resonate with modern and contemporary art and philosophy. The final chapter, therefore, examines aspects of Palissy afterlife through the themes of ceramics as 'fine art', *trompe l'oeil* and gender, and highlights the present relevance of his achievements, ideas and legacy.

Life and Strife

Bernard Palissy was born in Agen, southwest France, around 1510. He left some time in the 1530s, a period when famines and epidemics were devastating the region.[1] By the 1540s he had settled in Saintes, northeast of Bordeaux, which he called his home town and where he likely married. We do not know the name of his wife, whom he called his 'second persecution' and who bore him twelve children. Six died in infancy, three daughters and three sons reached adulthood: Marguerite, Marie, Catherine, Nicolas, Mathurin and Pierre.[2] Palissy never mentions any of them by name, but documents confirm that Mathurin and Pierre worked in their father's Parisian workshop. Catherine married a sculptor, Michel Saigel, and Marie a merchant from Sedan, Charlemagne Moreau, who sued Palissy in the 1570s on the grounds that he did not reveal the secret of his enamels which he had promised as a dowry.[3] Palissy referred to his wife as a persecutor when recounting the lack of support and the scorn he had to withstand from her while he was struggling to achieve his ceramic projects in the 1540s. Despite his later success, Palissy's relationship with his wife remained less than cordial. More than twenty years later, in the 1570s, as the Palissy household settled in Sedan, their frequent disruptive quarrelling led to their repeated exclusion from the local Protestant congregation. The documents left by their conflictual relationship speak of 'habitual scenes and insolent behaviour'.[4]

Before mastering the art of enamel, Palissy earned his living as a glass painter and surveyor. Surveying – mostly drawing territorial maps – provided much experience of the world but brought in only random assignments and income. Demand for stained glass and glass painters seemingly dried out in the 1540s, or perhaps as a fresh Calvinist convert Palissy had grown reluctant to decorate Catholic churches. Be that as it may, nothing remains or has been identified of these early works, yet Palissy must have been skilled enough to be occasionally employed by the courts of justice as he himself writes: 'In my town I was believed more learned than I really was in the art of painting, which was the cause I was often called to make figures for public trials.'[5]

In sixteenth-century French the expression *figures pour des procès* (figures for trials) refers generally to municipal maps drawn to resolve local territorial disputes or evaluate acreage for the purpose of taxation. Palissy fulfilled this type of assignment in 1543 when the royal tax collector hired him to draw the salt marshes of the Saintonge region. The 'figures' Palissy was called upon to draw, and of which nothing remains, could have also been images to be burned in effigy of those who escaped the grip of justice.[6] The doctrine of *execution en effigie* was developed in Italy and often used by the Inquisition. In sixteenth-century France effigies of escaped suspects must have been often in demand.[7] In these years of violent religious intolerance many leaders and followers of the Reformation had to flee France. One of them, Jean Calvin (1509–1564), took refuge in Ferrara, where he would meet and convert Palissy's first and most influential patron, Antoine de Pons (1510–1585).

Some time in the early 1540s, at the time of his first acquaintance with Pons, Palissy experienced a double epiphany, artistic and religious: he decided to produce ceramics and converted to Calvinism. Pons's support of the Reformation coincides with Palissy's active involvement in the new religion, and it is also

most probably thanks to him that Palissy endeavoured to produce ceramics. When he succeeded it was again down to Pons, who introduced him to Anne de Montmorency and to the queen mother, Catherine de' Medici (1519–1589), who were to become his patrons and protectors.

FIRST PATRONS

Antoine de Pons, count of Marennes, baron of Oléron and governor of the Saintonge region was a man of power, wealth and taste.[8] In 1533 he moved to Ferrara to marry Anne de Parthenay (c. 1510–1549) and join the court of Renée de France (1510–1574), daughter of French King Louis XII (1462–1515) and duchess of Ferrara since 1528.[9]

Anne de Parthenay, to whom the humanist Lelio Gregorio Giraldi (1479–1552) dedicated his *Historia poetarum* (1545), was one of Renée's childhood companions and maids of honour. Frequently praised for her learning and religion, she followed her mistress to Ferrara after Renée's marriage to Ercole d'Este was celebrated in Paris on 28 June 1528.[10] The union was a personal and political disaster. Not only did Ercole dislike Renée at first sight but by late August 1528 French power had severely declined in the Italian peninsula and turned the alliance sealed by the wedding into a liability.[11] To make things worse, Renée's personal involvement with the Reformation placed the duke of Ferrara in an increasingly uncomfortable position in relation to the pope and the Spanish Crown whose influence in Italy was rising as that of France waned.

In Ferrara, Pons not only accessed and participated in the material, artistic and intellectual culture of one of the most brilliant courts of the time but converted to Calvinism. His wife and Renée de France, of whom he became the confidant, were active supporters of the new religion and harboured some of its leading

figures, including Jean Calvin, Théodore de Bèze (1519–1605) and Clément Marot (*c.* 1496–1544), to mention the most well-known names.

Pons frequently travelled back to France on various missions until he left Ferrara for good in 1545, expelled with his wife from the duchess's entourage in the rising repression of Protestantism in the Italian peninsula. Back home the couple promoted the Reformation in their lands of Saintonge.[12] Anne welcomed Calvinist preachers sent from Geneva while her husband encouraged his vassals to abandon the Roman Catholic Church and join the Reformation. He protected Barthélémy Berton (*fl.* 1563–1573), who printed first in Marennes then in La Rochelle, vernacular translations of the Bible (a particularly controversial initiative at the time) and Calvinist literature, as well as Palissy's first two publications, the *Architecture et ordonnance de la grotte rustique* (1563) and the *Recepte veritable* (1564).

Pons's Reformist zeal faded after Anne's untimely death in 1549. Seven years later he married the very Catholic Marie de Montchenu (*c.* 1520–1560), maid of honour to the queen mother, Catherine de' Medici. From that time onwards he sided and remained with the Catholic party throughout the French Wars of Religion.[13] We find him as advisor to King Henry III (1551–1589) who received him in 1579 as one of the 118 knights of his very exclusive and often mocked zealous Catholic chivalric Ordre du Saint-Esprit. In 1576 the dedication to Pons of the French translation of the book by Polydorus Vergil (*c.* 1470–1555) on the history of inventors and invention (*De inventoribus rerum*) testifies to his broad intellectual interests.[14] Despite religious divergences he remained on cordial terms with Palissy, who dedicated to him his *Discours admirables* (1580), in which he fondly remembered the time of their first acquaintance: 'when you returned from Ferrara to your castle of Pons when lately it pleased you to speak to me of various sciences, namely philosophy, astrology, and other arts

drawn from mathematics'.[15] The arts drawn from mathematics were an appropriate subject of conversation with a surveyor, but it seems that Pons also influenced Palissy's own life paths by importing from Ferrara Calvinism as well as samples of the artistic avant-garde of the time: Italian maiolica plates.

THE ART OF THE EARTH

In the autobiographical section of the *Discours admirables*, Palissy recalls that he was once shown a white piece of enamelled earthenware so beautiful that he endeavoured to figure ways of reproducing it, and thus embarked on a gruelling decade of trials and errors.[16] This was certainly a commercial enterprise, if not a start-up. In the mid-1540s Palissy was struggling to support his growing family. Somehow he must have understood from Pons that producing ceramics would attract royal patronage and secure future prosperity.

Unlike goldsmiths, who used precious metals and gems, Palissy worked only with clay and glazing material. After a long decade of experimentation, he created his own style combining techniques inspired by maiolica, Limoges enamels and goldsmith work. Palissy's autobiographical narrative of his long, solitary and painful quest for the perfect white as the basis of enamel is odd insofar as this method was known at the time and had been practised in Europe for well over three hundred years. The story began in seventh-century Iraq when ceramists realized that the application and firing of tin dioxide on baked earthenware produces a white, waterproof and opaque coat. This method, tin glaze, entered the West around 1200 and spread to various European centres.[17] One of these centres was Saintes, Palissy's home town, and its region, which have dominated the production of ceramics since medieval times thanks to a natural supply of good clay and the trade routes of the nearby Bordeaux

region wine industry.[18] Saintes ceramics served to transport wines and have been excavated by medieval archaeologists all over northern Europe.[19] These ceramic containers were either grey or green, but in the village of Saint-Porchaire, located 15 kilometres (9 mi.) away from Saintes, some workshops produced, exclusively for the French Crown and a few aristocratic families, ceramics prized for their intricate architecture and above all for their deep and luminous white (illus. 3).[20]

Palissy, who had extensively travelled the region, was surely aware of these. His work shares with Saint-Porchaire ceramics the replication, in relatively inexpensive material, of the advanced

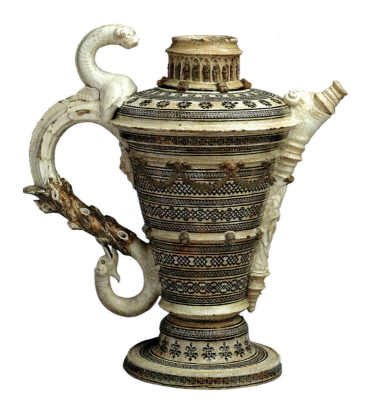

3 Ewer, Saint-Porchaire pottery, *c.* 1550, lead-glazed earthenware.

craftmanship that is characteristic of goldsmith work. Yet the account of his struggle confirms that he was somehow denied access to the knowledge necessary to produce white enamel. Advanced techniques developed and refined by generations of craftsmen and acquired during long years of apprenticeship were unlikely to be shared with a mature, ambitious, well-connected outsider and potential rival like him. As Palissy himself adds, in a marginal comment to his autobiography: 'the author has learned the art of the earth by himself.'[21] Indeed, he had to figure out the art of ceramics with what he understood from working in painting and glass painting. Part of his narrative inclines towards self-heroization but, as Palissy himself acknowledged, his tribulations were the plain outcome of his lack of experience.

Once he accessed knowledge, he kept it for himself. In the *Discours admirables*, when requested to reveal the secret of his enamels Palissy lists the ingredients but declines to reveal their correct proportions.[22] Instead he gives an account of the long and punishing years of trial and error he suffered to learn his trade, reminiscent of the miseries endured by the biblical figure of Job.[23]

According to Palissy, white is the basis of all colours; producing white enamel was therefore his first step towards mastering colour.[24] Enamel is a mineral paste made from crushed glass and pigments, applied over metal or clay and fired to melting point at temperatures ranging between 800 and 1800°C (1470 and 3270°F). As mentioned earlier, white tin glaze has been produced in Europe since the thirteenth century. It took Palissy more than two years to figure out this process. For this purpose he experimented with various solutions of crushed glass and pigments until he managed to produce a mixture that would finally melt into the deep smooth white he desperately sought. Repeated failures led him to try various kilns as his preparation would either not melt, burn or bake unevenly.[25] Discouraged, he abandoned

his project until 1543, when King Francis I (1494–1547) introduced a new tax on salt and Palissy was commissioned to inspect, measure and draw the salt marshes of Oléron Island and its surroundings. This new assignment inspired his interest in the origins and function of salt.[26] It also brought a much-needed cash injection thanks to which he could resume his experiments. He bought more glass and material that he painstakingly broke and crushed into more enamel preparations. He first went to a potter's workshop to fire his material, but the potters' kiln did not generate enough heat. He then asked the workers of a glass factory to bake the pot fragments he had covered with his enamel preparations. They melted as he hoped they would after about four hours.

Convinced that he had finally solved all his technical problems, Palissy decided to build his own kiln on the model of those of the glassmakers.[27] He writes that he spent more than eight months preparing his vessels and one month, night and day, crushing and grinding material to produce suitable glazing mixtures. This was a work-intensive task, and a most delicate one, as everything could be wasted at any time until the final firing.

Palissy does not describe the process of casting that has been reconstituted through the analysis of some of his remaining works.[28] Nevertheless, a manuscript composed in the 1580s, and recently edited, provides detailed instructions on the principal methods for casting plants and animals.[29] Preparation would begin with collecting shells and plants and capturing animals. They should be taken alive and killed gently, leaving no bodily traces of stress so that, once cast, they would look as lively as possible. After arranging lizards and snakes in suitable curves and coils with fine needles, Palissy would then take a first cast with a fluid plaster to record the most minute details. From this first fragile plaster print he made a positive in terracotta, from which he derived a second mould in a more durable material that was therefore suitable to

generate multiple casts of the same animal (illus. 4). By the 1580s this repertoire was large enough for him to settle the court case brought against him by his son-in-law by letting him use some of his casts without apparently disclosing the method and ingredients of their production.[30]

To prepare a rustic basin he arranged his animals and shells on a support and took a cast of the entire composition (illus. 5).

4 Bernard Palissy, cast of lizard, c. 1560, terracotta.
5 Bernard Palissy, cast for basin, c. 1555–65, terracotta.

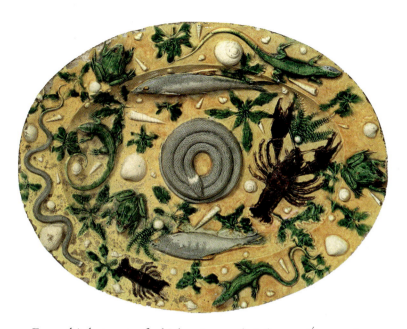

From this last cast, of which an example is kept at Écouen, he produced several rustic basins using a method that allowed for readjustments until the first firing. The Lyon basins illustrate this approach (see illus. 38–9). Palissy, with a painter's brush, would then apply his enamel preparations, each different for each animal, shell and plant. Next came the firing, the most critical stage during which excessive, insufficient or inconstant heat could ruin months of work. The Lyon basins record some of these struggles. While Palissy has succeeded in casting and glazing the intricately textured skins of the frog and lizards, the blackened extremities of their heads suggest that he barely avoided a disaster. Another example of these problems can be seen in the oval plate attributed to Palissy (c. 1550), where the enamel of the lizard and plants has dripped well over the confine of their forms (illus. 6).

In a much-quoted and illustrated sequence, Palissy recalled that to keep his kiln at the optimal temperature he had to feed

6 Attributed to Bernard Palissy, oval basin, c. 1550, lead-glazed earthenware.

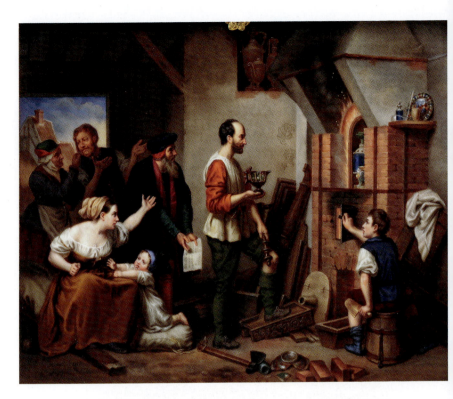

the fire first with some garden furniture and then with his own tabletops and floorboards. Paired with Palissy's allusion to his wife as oppressor, this account has struck nineteenth-century imaginations, inspiring an entire iconographic tradition representing him throwing household furniture in the fire in front of his dismayed family (illus. 7). The scene, however, would have taken place in a workshop, since Palissy refers to wooden boards rather than to beds, benches or chairs. The word 'tables' designates slabs of wood on trestles rather than dining-room centrepieces with precious figured woods carvings. Thus the entire episode has been understood as an exercise of mythification, perhaps less by Palissy than by his nineteenth-century Romantic admirers.[31]

7 After a painting by Charles Alexandre Debacq, *Bernard Palissy Burning His Furniture*, 1846, hard-paste porcelain decorated in polychrome enamels.

Be that as it may, the burning of tables and boards was only the beginning of Palissy's tribulations in enamelling. Even when he gained some control of his kiln temperature, his inexperience repeatedly generated new problems that would each time waste months of work-intensive preparations: unevenly crushed pigments would explode in the kiln and ruin an entire batch; incorrect placement in the kiln would make some pieces bubble up or burst; and on one occasion a gust of wind blew ashes that stuck to the enamel as it was melting and spoiled it.[32] Eventually he devised special boxes to isolate and protect each vessel during the firing process. He also tried different clay preparations, deconstructing and reconstructing his kiln, consuming his time and energy to the edge of exhaustion.

Having resolved all these issues, Palissy finally began producing and selling medals and jasperized plates (*plats jaspés*) that imitated the appearance of precious marbles with random veins of various colours, particularly prized in the sixteenth century

8 Follower of Bernard Palissy, dish, 17th century, lead-glazed earthenware.

(illus. 8, 17).[33] None of the finished pieces have been identified, yet some fragments survive. Thanks to this serial and commercial production, he could continue financing his experiments in rustic wares.

Jasperized enamels were made of a single mixture that melted uniformly. In the rustic basins with casts of animals, shells and plants, each element receives varying colours prepared with different minerals and pigments that would melt at a distinct pace, some burning, or spilling and wasting or devaluing the final product.[34]

It took Palissy up to fifteen years to solve all these problems and achieve satisfactory results Once he did, royal patronage promptly followed. By the early 1550s Pons had already recommended his work to Connétable Anne de Montmorency (1493–1567), the most powerful man in France after the king, who acquired a few ewers and rustic basins listed in the December 1556 inventory of one of his Parisian mansions.[35]

PROTECTORS AND SUCCESSES

The first half of Palissy's life was one of financial and professional struggle against a background of domestic conflict. The second half, equally enlivened by endless disputes with his wife, is when Palissy attained prosperity and fame thanks to his patrons and protectors who stood at the very apex of French society: Antoine de Pons; Anne de Montmorency, grand connétable of France; Catherine de' Medici, the queen mother; and three French kings: Henry II (1519–1559), Charles IX (1550–1574) and Henry III. These individuals made Palissy's enterprise possible. Their reaction to his work and his response to their demands and taste is a complex network. One of its outcomes is Palissy's social ascent from the status of provincial artisan to that of court artist – a position that secured him access to the leading intellectuals of

the time and most certainly inspired him to promote his ideas
in print as well as through public lectures.

ANNE DE MONTMORENCY

Despite the social distance that separated them, the relationship
between Pons and Palissy seems to have been founded on a
certain cordiality, as suggested by the dedication of the *Discours
admirables*. This was probably not the case with Montmorency and
Catherine de' Medici, who, as aristocratic patrons, dealt with
artists and artisans through intermediaries rather than directly.[36]
Montmorency's patronage nevertheless marks a turning point in
Palissy's career and self-fashioning. From a struggling maker of
original rustic earthenware, he became a master of grottoes and
fountain installations and felt empowered enough to print and
discuss his ideas in public.

The dedication of the *Recepte véritable* confirms that Palissy's
Saintes workshop was built at the connétable's expense and that
Palissy, officially in his service since the mid-1550s, had already
produced several vases and rustic basins for him. The two men
met at least once in 1556 when Montmorency, accompanied by
King Henry II and their entourage, visited Palissy's workshop in
Saintes. On this occasion Palissy probably convinced Montmorency
to commission him to construct an artificial grotto for which he
received payment eight years later (in 1564), and which he described
in his first publication *Architecture et ordonnance de la grotte rustique*.

The contrasts between the struggling Calvinist craftsman and
the Catholic lord are sharp and striking (illus. 9). Montmorency
began life as a childhood companion of François I (1494–1547),
whom he followed in the triumph of the Battle of Marignano
(1515) and supported in the disastrous Battle of Pavia (1525)
when, following the defeat of the French army, the king was cap-
tured by the troops of Emperor Charles V (1500–1558) and

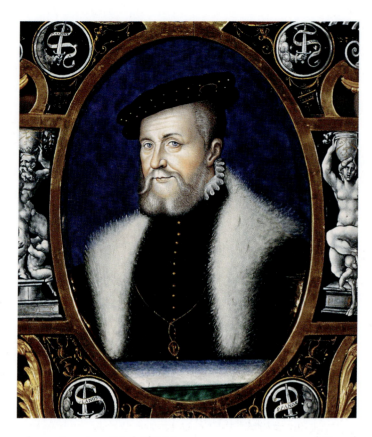

taken prisoner to Madrid.[37] Montmorency was appointed Grand
Master of the King's House in 1526 and grand connétable in
1538, a title that made him the most powerful man in France
after the king. François I disgraced him in 1541 after negotiations
with Charles V in which he failed to keep the duchy of Milan
under French control. He regained power in 1548 alongside
Henry II and then Charles IX. A military leader and administra-
tor, he also oversaw the organization and smooth running of court
life, the king's schedule and the many celebrations and cere mo-
nies, baptisms, weddings, funerals, royal entries and official visits.

9 Léonard Limosin, *Anne de Montmorency*, 1556, enamel.

He was usually accompanied by an entourage of about eight hundred horsemen.

Anne de Montmorency was a Catholic leader animated by a strong belief in civic and religious order. His hostility to the Reformation was fatal to many Huguenots as well as to himself. He slaughtered some with his own swords and spears on the battlefield and recommended the greatest severity towards those captured. He insisted in particular that Calvinist preachers through whom the Reformation was spreading in France should be 'immediately executed without long detention', either hanged or sewn in bags and thrown into rivers.[38] As military leader he suffered fatal wounds on 10 November 1567 while defending Paris at the head of the royal troops against the Huguenot army led by Gaspard de Coligny (1519–1572). According to the official account, Montmorency died two days later in the arms of King Charles IX.

The contents of the Montmorency Library as well as the works dedicated to him further confirm the distance between the Catholic connétable and the Calvinist craftsman. Unlike Palissy, Montmorency had apparently no interest in scientific and agricultural matters. He much preferred ancient and contemporary works of political and military history and enjoyed having these read to him while dining. Despite Palissy's dedication, Montmorency probably did not read the *Recepte véritable*. Perhaps emboldened by the short-lived peace treaty of Amboise (19 March 1563), implementing tolerance towards Protestants, Palissy appended to his considerations on agriculture an optimistic account of the Reformation in Saintes and a biography of Calvinist missionary and preacher Philibert Hamelin, who was executed in Bordeaux in 1557. Like many Catholic princes Montmorency employed Huguenot artisans and cared more about their skill than their religion. As is evident in the case of Palissy, religious divergences did not necessarily get in the way of social ascension. Some time before the death of the connétable he was promoted to the service

of the king and the queen mother, who entrusted him to build an artificial grotto for the garden of the Tuileries Palace.

Montmorency's patronage meant much more than financial security and social advancement; it placed Palissy's work in conversation with the arts of the time eloquently represented in the material world of the connétable, whose estate was considerable. At the time of his death, in addition to four Parisian mansions, his biographer Francis Decrue listed more than 130 castles, lands and lordships.[39]

The period during which Montmorency employed Palissy coincides with his return to politics (1548–59; 1560–67) and with the active and festive years of Écouen castle, near Paris, which has since become the Musée National de la Renaissance. Acquired in 1522 and renovated at the time of the granting of the connétable's office, the castle was used to receive the king and foreign monarchs and dignitaries as well as their retinue, which usually numbered several hundred people. The French king stayed at Écouen no less than fourteen times and Emperor Charles V was hosted there, as well as the Spanish ambassadors who came in 1559 on the occasion of the Treaty of Cateau-Cambresis. Some time in the early 1550s, with their ritual dinners, banquets and princely celebrations, Écouen and the Parisian mansions of Montmorency became the new backdrop for the work of Saintonge craftsmen. The inventories of Montmorency's Parisian mansions provide a good overview of his material and artistic environment. His collections included the cutting-edge and the big names of the time: Raphael, Leonardo, Michelangelo, Rosso Fiorentino, Primaticcio; antique art; some modern works with mythological and religious subjects; and a collection of old and modern maps, city views and portraits.

Maps and city views converge towards Montmorency's military vision of the world complemented, in the inventory, by an impressive collection of parade and combat arms and armour. The

portraits of kings, parents and ancestors are links of a long chain extending from the effigies of Roman emperors and generals to the connétable's own lineage, which traced back to the upper classes of the Roman Empire. Religious subjects, however, dominated his environment, both in the Parisian mansions and in Écouen castle with its twelve biblical-themed fireplaces and tapestries. The inventories also mention a set of maiolica and, of course, plates, platters and basins 'in the manner of Saintes', most probably by Palissy. Under the section 'Émaux et faiences' the clerk notes:

> A tree in the shape of a rock, strewn with shells and
> animals
> Two oval-shaped basins with figures of reptiles
> An oval basin, decorated with animals . . .
> An oval basin, in the shape of a rock, strewn with shells
> with several animals of various sizes . . .
> A coral rock serving as a fountain, where are several
> reptiles.[40]

In this context the fauna and vegetation of Palissy's ceramics also connect with the foliage, flowers and vegetables that frame the biblical imagery, the portraits, trophies of arms and emblematic devices of Écouen castle, as well as the borders of the miniatures in the connétable's prayer book kept in Chantilly. The natural world is also present in the background as confirmed by the nine tapestries listed in the section 'Verdures et feuillages' of the inventory of the Parisian mansion.[41] Far from being exclusive to the taste of Palissy's first patrons, the rustic style and world offer a glimpse of the early modern aristocratic relationship with nature. The natural world played an important part in the life of Montmorency who, like his royal and princely peers, dedicated a least one-third of his life to the masculine joys of hunting.

FIRST GROTTO

The oval basins mentioned in Montmorency's inventory were probably similar to those currently kept in Lyon and Paris (illus. 37–9). They could have been used to collect the water with which banqueting guests would rinse their hands between courses. Their never-seen-before appearance suggests that they could have been displayed on a dresser with other precious wares, such as goldsmith work or Saint-Porchaire pottery, but they could have also been used to present food. We simply do not know. What is certain, however, is that Montmorency was sufficiently pleased by the objects he owned, and convinced enough by Palissy's eloquence, to commission him to build an entire grotto installation in the same ceramic medium as the rustic basins.

By the second half of the sixteenth century, artificial grottoes had become status symbols of wealth and learning. The fashion for grottoes originated in Italy and came to France in the 1540s.[42] The Italian painter and architect Francesco Primaticcio (1504–1570), who served the French kings from 1532 until his death, and the architect and theoretician Sebastiano Serlio (1475–1554) are credited for creating the first important French artificial grotto, the Grotte des Pins (1540–43), at Fontainebleau (illus. 10).[43] Royal patronage inspired an aristocratic fashion in France as the number of artificial grottoes expanded in the following decades eventually to become standard features of princely gardens. Pierre de Ronsard (1524–1585) in his *Epître* (1557) to the Cardinal Charles de Lorraine (1524–1574) and his *Chant Pastoral* (1559) mentions the grotto built in Meudon as a place of rest for the Muses and for King Henry II.

It is most likely in a spirit of friendly rivalry with the cardinal that Anne de Montmorency commissioned Palissy's first grotto. We do not know whether it was ever installed or if the material prepared for this project was reused for the later commissions. In the following years Catherine de' Medici commissioned a

grotto from her architect, Philibert de l'Orme (1514–1570), for her castle at Montceaux-en-Brie and one from Palissy for the Tuileries gardens – on the grounds of the present-day Louvre which was at that time the Royal Palace.

Renaissance grottoes were a revival of the Classical nymphaeum, a pre-Christian oratory for which natural caves were adapted as sanctuaries, reservoirs and assembly rooms and decorated with frescoes, mosaics, carvings and statues.[44] In the ancient world, grottoes are the dwelling places of sybils and of aquatic divinities associated with forests and streams. Usually irrigated by fountains or natural sources, the artificial grottoes of Renaissance princely gardens were havens of coolness during the hot summer months. As secular temples often dedicated to the Muses, goddesses of poetic inspiration, they were meant for social or intimate interaction and meditation.

Artificial grottoes are also early modern representations of nature. As idealized natural dwellings they are one of the

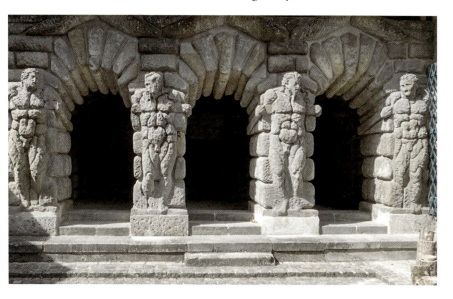

10 Francesco Primaticcio, entrance to the Grotte des Pins, Fontainebleau, *c.* 1540.

foundations of rustic architecture. Figured marbles, woods and rocks were understood as forms of natural artistry, and grottoes showcased Nature as architect. In this spirit Palissy's approach to grottoes led him to expand his rustic basins into ambitious installations exploiting the combined possibilities of ceramics and natural elements.

REFORMATION AND RELIGIOUS PERSECUTIONS

As Palissy was about to reach his professional goals, much trouble came to him by way of religion as he was a Huguenot in religious war-torn France. His allegiance to the Reformation threatened the work which should have crowned over a decade of efforts, for in 1562, as he was preparing the Montmorency grotto, he was arrested and jailed in Bordeaux on charges carrying the death penalty for his participation in the Huguenot riots that rocked Saintes in 1562.

The word 'Huguenot' designates French Protestants, mostly Calvinists. It started as a mocking word adopted in defiance by those being derided. Palissy might have been aware of the Reformation early in life as the movement was already spreading in his native Agen through the popular, notable and magistrate classes. He received further impetus from his first patrons, Antoine de Pons and Anne de Parthenay, who came back from Italy converted to the Reformation by Calvin himself.[45]

The Reformation began in France as a moderate affair. French humanist sympathizers of Martin Luther (1483–1546) such as Jacques Lefèvre d'Etaples (1455–1536) and Guillaume Briçonnet (1472–1534) earnestly sought a better understanding of the Bible thanks to the tools of humanist philology. Their successors, Jean Calvin among them, were revolutionaries (illus. 11). Like Luther, Calvin felt that the Church had strayed from its early ideals and that a thorough reformation was necessary to eliminate

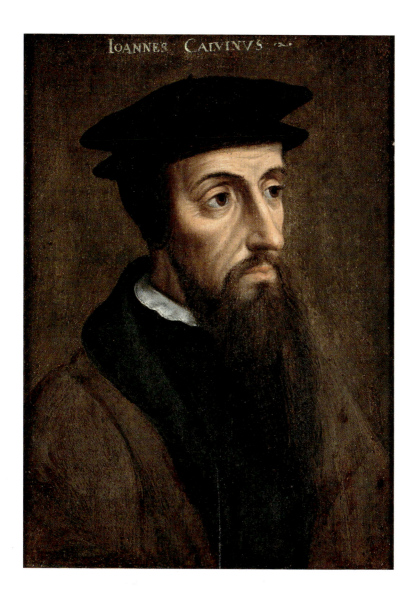

11 Anonymous, *Jean Calvin*, 1550, oil on panel.

the many superstitions accrued during the centuries separating the present from the first centuries of Christianity. Unlike Luther, who tolerated religious images, Calvin rejected them as idolatrous and advocated their removal from churches, inspiring waves of iconoclasm throughout Europe north of the Alps and the Pyrenees; an estimated 40,000 French churches had their images removed or broken. Calvin considered the Catholic Mass to be sacrilegious, rejected the cult of saints and of the Virgin as well as the dogma of the real presence of Christ in the host. Calvinists declined to attend Catholic Mass, which they considered an abomination, and instead met in private assemblies with a pastor reading excerpts of the Bible.

In October 1534 the question of the Mass unleashed the first wave of persecutions against French Protestants. Several pamphlets attacking this Catholic ritual and denouncing the superstitions of the Church were posted anonymously in Paris and other French towns, including Amboise, on the door of the king's chapel. This last initiative considerably angered François I and prompted a campaign of brutal repression leading to the torture and execution of those found responsible for the so-called *affaire des placards*. Some escaped, including Calvin, who took refuge in Ferrara at the court of Renée de France where he converted many to the new religion, including Antoine de Pons and his wife Anne de Parthenay, Palissy's first patrons and protectors. After his stay in Ferrara, Calvin settled in Geneva. He founded a church and an academy to train missionary pastors and preachers to set up Reformed congregations all over Europe.

By then, despite the protection granted to Protestant figures by some members of the royal family, practising the new religion had become increasingly risky. From the 1530s onwards all those caught preaching Reformist ideas, rejecting the Mass, the cult of images or contesting the efficacy of prayers to the saints and the existence of purgatory were burnt alive in public after enduring

abominable tortures. Despite these early setbacks and barbaric repression, Protestantism permeated all layers of French society, from the peasantry to the nobility. Things began to change in 1559 when the treatise of Cateau-Cambresis ended decades of war between France and Spain and granted French Catholic nobility the full support of the Spanish Crown to rid their country of Protestantism. By then many French aristocratic families had sided with the Reformation and thus France was ready for a civic and religious war. It unfolded in eight episodes, concluding in 1598 with the Edict of Nantes, signed by King Henry IV (1553– 1610) – but later revoked by Louis XIV (1638–1715), who outlawed Protestantism again in 1685.

Until the early 1550s Antoine de Pons and Anne de Parthenay facilitated the establishment of Reformed congregations in their territories. Thanks to their initiatives Palissy struck an acquaintance with itinerant preachers educated in Geneva and collaborated in the establishment of a Reformed community in his hometown of Saintes. He may even have occasionally acted as a pastor and assisted the ministry of Philibert Hamelin, the Calvinist preacher who was burnt alive in Bordeaux in 1557.[46]

By the time Pons sided with the Catholics in the mid-1550s, many missionaries sent from Geneva had worked so well in implanting the Reformation that Saintes was a stronghold of the new religion. In May 1562 Protestant forces took over but were crushed and expelled in October of the same year by the Catholic army who also sacked the city. Palissy was arrested for his alleged participation in the public disorders and iconoclastic outbursts brought by the Huguenot takeover of 1562. Transferred to Bordeaux, he awaited trial while his workshop was at risk of looting. To get out of trouble, he wrote from jail the *Ordonnance et architecture de la grotte rustique*, printed in early 1563 by Barthelemy Barton and dedicated to Montmorency. The *Ordonnance* is a detailed description of the grotto Palissy was preparing for the

connétable, as much as a plea to intercede in his favour – or lose
the extraordinary work which he had financed for the past seven
years.

THE *RECEPTE VÉRITABLE* AND PALISSY'S ARTISTIC RISE

The plea succeeded. Palissy was freed and returned to his kilns.
The year 1563 was good, an optimistic time brought by the short-
lived peace treaty of Amboise allowing Protestants to practise
their religion freely, as long as they celebrated their cult outside
city limits.

The rise in status brought about by Montmorency's patronage
coincides with the beginning of Palissy's publishing output; he
wrote the fifteen pages of *Architecture et ordonnance de la grotte rustique*
from prison in the winter of 1563 (illus. 12). The *Recepte véritable*
printed only a few months later is 120 pages long and concludes
with the promise of another book on topics Palissy expounded
in public lectures, later published as his *Discours admirables* (1580).
Princely patronage empowered Palissy not only to expand his
work from tableware to entire environments but to discuss his
ideas in print and in public. In September 1563 he published the
Recepte véritable in which he expounded his philosophy of agricul-
ture, proposed an ensemble of gardens, grottoes, fountains and
fortifications and concluded with an account of the establish-
ment of the Calvinist church of Saintes. The title page (illus. 13)
unveils the programme:

> True benefit, by which all the men of France will
> be able to learn how to multiply and increase their
> treasures.
> Item, those who have never had knowledge of letters,
> will be able to learn a philosophy necessary to all the
> inhabitants of the earth.

Item, in this book is contained the design of a garden
as delectable & useful in invention as was ever seen.
Item, the design & arrangement of a fortress town, the
most impregnable that man has ever heard of, com-
posed by Master Bernard Palissy, earth worker and
inventor of the rustic figulines of the King and of
Monseigneur the Duke of Montmorency, Peer and
Connétable of France.

In old French the word *recepte* – *recette* in modern French –
has two distantly related meanings. The first is a familiar fin-
ancial expression and refers to income, as in *receptes et depenses*,
income and spending. The second meaning is that of recipe, a
piece of practical knowledge, a list of ingredients and a method
of combining them. Recipes are building blocks of the history
and circulation of knowledge.[47] In medieval times manuscript
compilations of recipes were bound with texts extending from
alchemical and medical literature to collections of practical house-
hold advice. With the advent of print, recipe books became an
independent pan-European genre. Typical titles like the *Bastiment
des receptes* or the *Secrets* of Isabella Cortese offer a broad assort-
ment of recipes to fix domestic issues, from skin cleansing to
infertility.[48]

When he selected the title of *Recepte véritable*, Palissy was surely
aware of this literature which sometimes verged on charlatanism.
Yet the *Recepte véritable* does not contain any recipes; it begins with
a method for preparing compost, moves on with Palissy's vision
of an ideal garden and then of a fortress followed by an account
of the establishment of the Reformation in Saintes and its region.
In fact, there is no recipe in any of Palissy's literary remains. The
title of *Recepte véritable* plays on the double meaning of the word
recepte: income and recipe. The title might be better translated as
'the true income' or the 'true benefit' that one would receive from

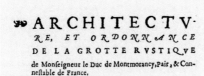

Palissy's philosophy of agriculture, which approaches soils, minerals, plants and animals as sentient and intelligent beings. The *Recepte véritable* combines entrepreneurship and Calvinist utopia; it is both the spiritual benefit and the concrete income one would receive from correctly fertilizing the earth and understanding its workings. It is not charlatanism since Palissy's method of making compost is correct and has even earned him a place of distinction in the history of fertilizers.[49] With his usual business acumen Palissy observes that about 4,000 aristocratic households could benefit from his agricultural expertise, gardening and landscaping inventions.[50] Thus he was addressing an elite audience used to seeing the word *recepte* in compilations of domestic recipes as much as

12 Bernard Palissy, *Architecture et ordonnance de la grotte rustique* (La Rochelle, 1563), title page.

in the familiar annual reports of the *receptes et depenses* of their estates.

The sections on grottoes and gardens of the *Recepte* confirm that Palissy has reached a full mastery of his medium. From his earlier struggles to produce white enamel he has progressed to

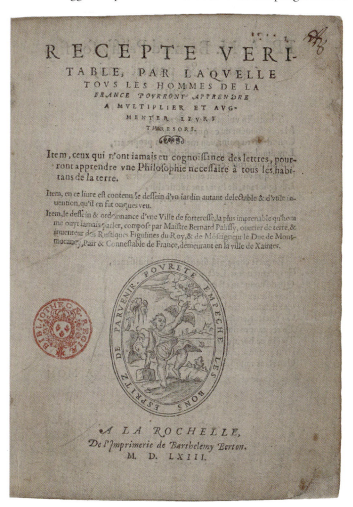

13 Bernard Palissy, *Recepte véritable* (La Rochelle, 1563), title page.

the point of envisaging entire installations of multiple grottoes irrigated by fountains and integrated to gardens of his own design. By then, in 1564, he has already received royal patronage, as confirmed by the title page of the *Recepte* which reads: 'Maistre Bernard Palissy, ouvrier de terre, & inventeur des Rustiques Figulines du Roy, & de Monseigneur le Duc de Montmorency, Pair & Connestable de France, demeurant en la ville de Xaintes.'

Montmorency paid Palissy in 1564 for his work on the grotto, but we do not know whether the project was ever completed and installed in one of the connétable's castles – he owned more than 130. By this time Montmorency had introduced Palissy's work to Catherine de' Medici, thanks to the intervention of whom he was freed from jail. She was shortly to become his most important patron and protector. Palissy thanked her in the second dedication of the *Recepte* and proposed to build a garden for her. His plea was well received as he entered her service around 1565, where he remained until her death in 1589. From this period onwards Palissy contributed to the sophisticated, lavish and propagandistic festive culture of the queen mother.

CATHERINE DE' MEDICI

Catherine was born in Florence on 13 April 1519, the daughter of Madeleine de la Tour d'Auvergne (1495–1519) and Lorenzo de' Medici II (1492–1519), grandson of Lorenzo il Magnifico (1449–1492) (illus. 14). Orphaned shortly after her birth, Catherine grew up in the Florentine convent of Le Murate until 1533 when, thanks to the brokerage of her uncle, Pope Clement VII (1478–1534), she was wedded to Henry, second son of François I. She became queen in 1547 when her husband accessed the French throne as Henry II (illus. 15). After Henry's untimely death of wounds sustained in a tournament (August 1559) and following the brief reign of François II (1559–60), Catherine entered the

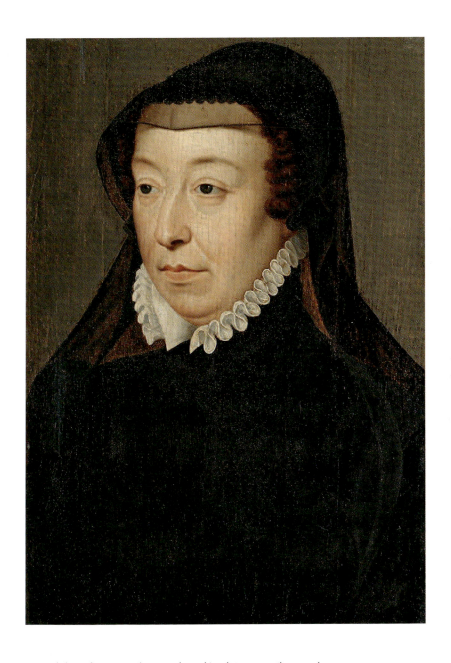

14 Workshop of François Clouet, *Catherine de' Medici*, c. 1550, oil on panel.

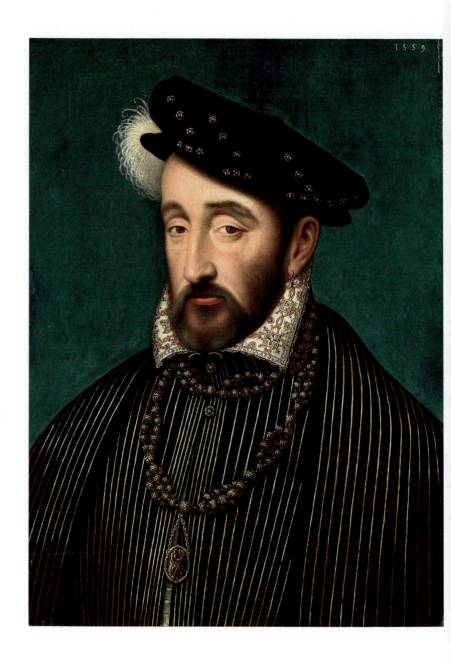

15 Workshop of François Clouet, *Henry II*, c. 1559, oil on panel.

political arena, taking over the regency until her second son, Charles IX, came of age. After his death in 1574, Catherine's third and favourite son, Henry III, relinquished the Polish throne to be crowned king of France in 1575. The last Valois kings, Catherine's three sons were not particularly outstanding individuals, often more inclined to the pleasures of hunting and feasting than the toil of administration. Their lukewarm interest in state affairs meant that Catherine and her entourage influenced French politics for most of the second half of the sixteenth century. She was not always in control. The St Bartholomew's Day massacre on 23–4 August 1572, which cost some 3,000 lives in Paris and triggered a season of communal violence against Protestants in other French towns, was a major setback to her policy of religious tolerance.

The queen mother was also a prominent collector and patron of architects, artists and artisans. She certainly saw herself in a spirit of rivalry with her Tuscan relatives, the Medici of Florence, whose patronage of the arts had produced the first ever history of art, the *Lives of Artists* by Giorgio Vasari (1550; 1568), founded the first official art academy and contributed to some of the most elaborate celebrations of the time.

From the fifteenth century onwards, the core purposes of Medici art patronage and festive policy were political and propagandistic. Catherine de' Medici adopted the same approach as her Florentine ancestors and relatives. Her sons may have been a declining dynasty, but this was in contrast to their festive tradition, which Catherine instigated and shaped into an extravagant and exorbitant swan song through which she expressed her hopes of a prosperous present and a peaceful future. She spent considerable sums on festivals, triumphal entries and court entertainments, imposing an image of herself and of the monarchy through which she intended to unite the nobility and the people and promote a policy of tolerance.[51] She even had her festive

political agenda woven into a set of tapestries known as the Valois Tapestries. They represent a selection of tournaments, hunts, water games and triumphal processions that took place during her long reign. The water festival with a sea monster illustrated here took place on the occasion of the meeting of the Hapsburg and Valois courts in Bayonne in 1556 (illus. 16).[52] It is merely an example of one of the many elaborate entertainments that

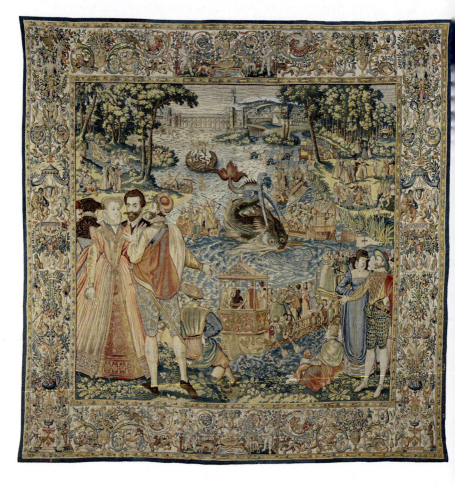

16 *Water Festival at Bayonne, c.* 1580–81, tapestry.

accompanied one favourite French royal ritual, or ceremonial entry: the *entrée joyeuse*.

The French monarchs loved such pomp and tradition.[53] François I toured his kingdom in the years 1516 to 1521 and again in 1531–4. His successor Henry II performed more than twenty royal entries between 1548 and 1551, while in the same years Charles V was touring his empire from Spain to the duchy of Milan to the Netherlands to introduce his son Philip II as his successor. The performance of *entrées joyeuses* peaked with Henry's successor, Charles IX. Between 1564 and 1566 Catherine de' Medici, with a view to bringing unity to the kingdom and introducing the teenage King Charles to his subjects, set up a grand *tour de France*, which prompted the organization of more than one hundred ceremonial entries. A book was published to record the events but was unfortunately not illustrated.[54]

After the ritual presentation of the keys of the town, symbolizing submission in return for royal protection, the king and the court would parade the city, receive the homage of the different corporations and nations and preside over tournaments, plays, military games, music, banquets and balls held in his honour.[55] Ceremonial entries prompted the invention and construction of fountains, moving sculptures, triumphal arches and floats. Accounts of floats and triumphal arches almost invariably mention garlands of vegetables, fruits and flowers: some real, some artificial, all evocative of the themes of fertility and prosperity. This recurrent imagery of royal entries suggests that there was plenty of room and much need for Palissy's naturalistic production, which the queen mother and the young King Charles had the opportunity to examine themselves in May 1564 during the Saintes stage of their royal tour.

On this occasion the queen and her retinue visited Palissy's workshop, which by this time had become a subject of aristocratic interest and curiosity, if we are to believe the impressive list of

visitors mentioned in the introductory section of the *Ordonnance de la grotte*. The preparation of the Montmorency grotto must have been well advanced since Palissy had received payment three months earlier, in February 1564, and he must have had plenty of material on display to interest the queen and her entourage, as well as some copies of his freshly printed *Recepte véritable*.[56]

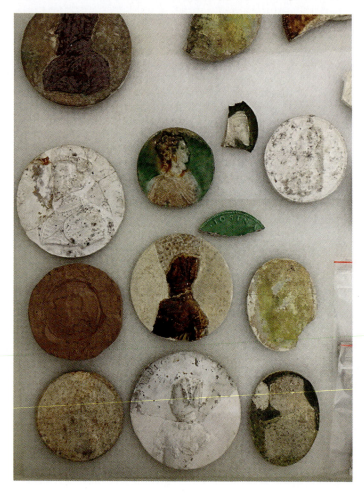

17 Fragments and rejects of medals from Palissy's workshop.

Impressed by what she saw and read, she commissioned a grotto for the Tuileries Palace. In retrospect the section on grottoes and gardens of the *Recepte véritable* turned out to be a successful funding application thanks to which Palissy moved from his provincial home town of Saintes to Paris to produce the grottoes and fountains he had imagined.

In 1565 Palissy moved to Paris and began working in the Tuileries gardens near the royal palace, where a workshop formerly used to produce tiles was converted to his specification.[57] This is the space which was excavated in the nineteenth and twentieth centuries. The findings – mostly fragments, moulds and reject casts of medals, plaquettes, jasperized plates and even spoons – testify to the activity of the new workshop (illus. 17). Some of its productions may have featured on the ephemeral triumphal arches celebrating *entrées joyeuses*, yet after the death of Charles IX in 1574, his successor, Henry III, anxious for his security, performed fewer entries as the court settled in the Ile de France region for financial and safety reasons.[58] The decrease in such ceremonies during the reign of Henry III (1574–89) is, however, compensated for by the proliferation of lavish court entertainment in which Palissy's work was seen and admired.

PARIS – SEDAN – PARIS

By 1567 the French Wars of Religion were raging again. Montmorency, at the head of the Catholic troops, died on 12 November 1567 of wounds sustained at the Battle of Saint-Denis against the Huguenot army led by Coligny. In the meantime, Palissy, now 'Ouvrier de terre et Inventeur des rustiques figulines du Roy et de la Royne sa Mère', had settled in his new Parisian headquarters, residing in a house of the nearby Faubourg Saint-Honoré.

The following years were dedicated to the preparation and installation of the Tuileries grotto and garden fountains for

which Palissy and two of his sons, Nicolas and Mathurin, received payment in 1570. In 1573 the correspondence of the Polish ambassadors mentions a fountain in Palissy style, and the grotto is briefly described two years later, in May 1575, by the Swiss ambassadors who visited the Tuileries.[59]

In June 1572 Palissy received 24 livres tournois (approximately £2,000 at today's rate) from Renée de France whom we have already encountered in the 1530s as the duchess of Ferrara, host of Calvin and confidant of Palissy's first patrons, Antoine de Pons and his wife Anne de Parthenay.[60] After the death of her husband Ercole d'Este in 1559, the estranged duchess returned to France and settled in her estate of Montargis, south of Paris, where she continued sheltering Protestants until her death in June 1575. Three years prior to this she joined the court for the preparation of the marriage of Marguerite de Valois and Henri de Navarre, the future Henry IV.[61] Expected to bring Catholics and Protestants together, the event instead prompted the St Bartholomew's Day massacre (illus. 18) of 23–4 August 1572.

It is not clear whether Palissy was informed of the forthcoming bloodbath, since historians are not themselves clear whether the massacre was planned or spontaneous. Perhaps the duchess intended to assist Palissy and his family in leaving Paris, where religious tensions were in any case palpable. Be that as it may, the donation certainly helped: by August 1572 Palissy and his family had moved to Sedan, in the Ardennes region of northeastern France, taking refuge in the lands of the Duc de Bouillon, another French aristocrat who looked favourably upon the Reformation. We know that Palissy acquired a house in the region he called Mont Palissy.[62] Although his Sedan workshop was active, along with the Tuileries workshop, the documentary remains of these years concern mostly the various disruptions to the local congregation caused by Palissy's quarrelsome temper and tempestuous relationship with his wife. We also know of the court case instigated

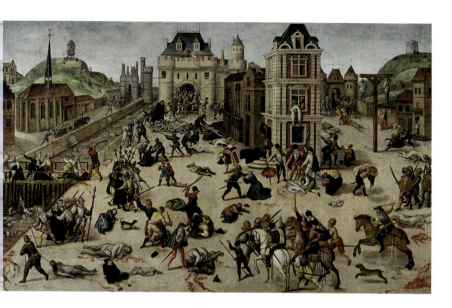

against Palissy by his son-in-law, Charlemagne Moreau, on the
grounds that he did not reveal the secret of his enamels, which he
had promised as a dowry. The untimely death of Palissy's daughter,
Moreau's wife, and the issue of her children's inheritance triggered
further disputes between Moreau and Palissy, eventually settled
in 1584 after lengthy negotiations.[63]

In 1575 Palissy returned to Paris where he delivered public
lectures later collected, edited and printed in 1580 as his *Discours
admirables*. Such lectures and disputations of theses were a common
Parisian entertainment and, only a few years after Palissy, the
Italian philosopher Giordano Bruno (1548–1600) also offered
public talks. Unlike Bruno's, whose initiative ended in fiasco as he
could not reply to the objections brought forward by a member
of the audience, Palissy's presentations seem to have gone well.
Entrance included paying a fee 'to ensure the seriousness of the
audience'. The list of the attendees provided by Palissy includes
distinguished members of the scientific and medical communities.

18 François Dubois, *St Bartholomew Massacre*, 1574, oil on panel.

The topics discussed correspond to the main chapters of the *Discours admirables* listed on the title page (illus. 19):

> Admirable discourses on the nature of waters and foun-
> tains, both natural and artificial, metals, salts & salines,
> stones, earths, fire & enamels. Along with many other
> excellent secrets of natural things.
> Plus a treatise on the marl, very useful & necesary, for those
> who dabble in agriculture.
> The whole drawn up by dialogues, in which are introduced
> Theory & Practice by Master Bernard Palissy, inventor of
> the rustic figurines of the King, and the Queen his mother.

The ceramic production of these years remains unidentified, a state of things which has led to the suspicion that Palissy principally concentrated on his research, lectures and writings. He might have commuted between Sedan and Paris directing his workshops with the help of his sons. Furthermore, from the time of his arrival in Paris his work is mentioned in two important and memorable court festivals, the *Ballet des Polonais* of 1573 and the *Balet comique de la royne* of 1581. Both plays featured elaborate sets of artificial grottoes and rocks erected for the occasion as well as several casts bearing his naturalist signature, as we will see later.

Aside from these prestigious contributions to the most memorable ephemeral events of his time, of which he himself says nothing, Palissy was seeking more patronage. In a brief address, printed after the dedication and advice to the reader of the *Discours admirables*, he invites anyone interested in his ideas to contact him through his printer to commission a fountain from him, for which he will happily produce a model. We do not know whether this advertisement brought him further patrons and acquaintances. Although by then he had established his reputation and was still employed by the royal family, he was looking to

DISCOVRS AD-
MIRABLES, DE LA NA-
TVRE DES EAVX ET FON-
TEINES, TANT NATVRELLES QV'AR-
tificielles, des metaux, des sels & salines, des
pierres, des terres, du feu & des emaux.

AVEC PLVSIEVRS AVTRES EXCEL-
lens secrets des choses naturelles.

PLVS VN TRAITE' DE LA MARNE, FORT
vtile & necessaire, pour ceux qui se mellent de
l'agriculture.

LE TOVT DRESSE' PAR DIALOGVES, E-
squels sont introduits la theorique & la practi-
que.

Par M. BERNARD PALISSY, inuenteur des rustiques
figulines du Roy, & de la Royne sa mere.

A TRESHAVT, ET TRESPVISSANT
sieur le sire Anthoine de Ponts, Cheualier des ordres
du Roy, Capitaine des cents gentils-hommes, & con-
seiller tresfidele de sa maiesté.

2596

A PARIS,
Chez Martin le Ieune, à l'enseigne du Serpent,
deuant le college de Cambray.
1580.
AVEC PRIVILEGE DV ROY.

19 Bernard Palissy, *Discours admirables* (Paris, 1580), title page.

top up his income as much as to implant his religious and philosophical ideas through the commission of garden designs and fountains in aristocratic households.

Despite the apparent success of the lectures, of the book and of the *Balet comique de la royne,* more hardship would come by way of the French Wars of Religion. On 7 July 1585, besieged by the Catholic troops, King Henry III was forced to sign the Treaty of

20 Cesare Vecellio, *Henry III,* 1574, woodcut with hand colouring.

Nemours which outlawed Protestant worship (illus. 20).[64] Pastors
were ordered to leave the kingdom and French Protestants had
either to abjure their religion, go in exile within six months or
face capital punishment. Palissy ignored the edict, was arrested,
freed, rearrested and jailed in 1588. According to his contempo-
rary, the poet Agrippa d'Aubigné (1552–1630), King Henry III
visited Palissy in jail, begging him to renounce Calvinism in
exchange for his freedom. Otherwise, said the king, 'I will be con-
strained to leave you in the hands of my enemies.' Palissy of course
refused to abandon his religion and allegedly replied, 'I pity you
who pronounced these words: *I am constrained.* This is not to speak
as a King.'[65] Another anecdote reported by the jurist and diarist
Pierre de L'Estoile (1546–1611) illustrates Palissy's indifference
to death. The prison governor, Bussi-Leclerc, once entertained
himself by having a fire lit and telling Palissy that his final hour
had come. He would then observe his serene willingness to die in
the flames rather than convert to the Roman Catholic faith. Thus
Palissy spent the last months of his long life in jail. According to
Pierre de l'Estoile, he sold a cabinet he made to Bussi-Leclerc,
presumably a wooden chest with drawers and shelves, for the
sum of 100 écus, thanks to which he could afford to have food
delivered to him in prison.[66]

Although sentenced to death for being a Calvinist, Palissy
was not burned alive but died 'of poverty, need and bad treat-
ment'.[67] Pierre de L'Estoile, who wrote these lines, was a personal
friend. Ten years earlier he had signed the privilege of the *Discours
admirables*. In the ten volumes of his diary, the news of Palissy's
death prompts a rare personal expression of affection and sym-
pathy. Pierre de l'Estoile was also on Palissy's mind during his
last moments:

> This good man, when dying, left me a stone which he
> called his Philosopher's Stone, which he assured me was

a human skull which the length of time had converted into stone, with another, which he used in his works. These two stones are in my cabinet, I love them and carefully keep them in memory of this good old man, whom I loved and relieved in his necessity, not as I would have liked, but as I could.

The aunt of this good man, who brought me the said stones, returned there the next day to see how he was, and found that he was dead. And Bussi told her that, if she wanted to see him, she would find him with his dogs on the rampart, where he had dragged him, like the dog that he was.[68]

Thus one of Palissy's last deeds was the gift of two stones by which he wished his friend to remember him. As the rest of this book will make clear, these stones embody the two main pursuits of Palissy's life. The fossilized skull stood as proof and illustration of his ideas on the petrifying power of underground water, a central theme of his natural philosophy. The 'stone with which he worked' could be a tool, but more likely it is one of the many minerals he cast and enamelled. It is to this ceramic work and its reception that we shall now turn, before examining Palissy's philosophical ideas.

TWO
Works

alissy developed his art and style from elements which he borrowed from the main ceramic traditions of his time. His productions and writings confirm that he was aware of at least three forms blooming within Renaissance courts and most likely represented in the Pons household: maiolica, enamel and the art of casting.

Italian maiolica was the exuberant artistic vanguard of the time (illus. 21). In the history of ceramics, maiolica stands out as the glorious outcome of a conquest of colour that took place over several centuries. The ceramist's palette began its expansion with the introduction of tin glaze in thirteenth-century Europe and peaked three hundred years later in the Italian Renaissance with maiolica, a multicolour new genre aspiring to outshine painting.[1] Maiolica plates are pictures drawn and painted against a dry background with baked rather than dried colours. The five principal production centres – Gubbio, Urbino, Faenza, Deruta and Venice –broadcast secular, classical and sometimes religious themes, from mythological fables to modern allegories, emblems and even portraits of famous men and beautiful women.[2] Thus in cultural history, maiolica, like prints, are transmitters of iconography, frequently reinterpreting compositions taken from well-known paintings. By the second half of the sixteenth century maiolica plates featured on French princely dressers and dining tables while workshops in Rouen were beginning to

produce plates imitating Italian models. Anne de Montmorency, Palissy's most powerful patron, owned a famous Italian maiolica set and Catherine de' Medici several.[3]

Palissy knew of the production of the workshop of Florentine Luca Della Robbia (1400–1482), in particular its enamelled wreath of brightly coloured fruits, flowers and leaves ornate with the occasional lizard or frog, framing classical or religious figures from Virgin and Child to Roman emperors (illus. 22). Although he praised the workmanship of Della Robbia, which he probably examined at the Chateau de Madrid near Paris, he criticized the thickness of the ceramic paste, which muffed the finely textured skin of cast leaves, fruits, vegetables and animals.[4]

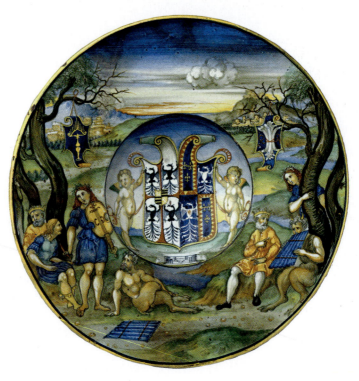

21 Nicola da Urbino, armorial plate (tondino), *The Story of King Midas*, c. 1520–25, maiolica (tin-glazed earthenware).

While maiolica was rising in Italy, the French enamellers of Limoges were developing a style that closely imitated painting. The most well-known, Léonard Limosin (1505–1577), had ascended to prominence and prosperity when entering the service of the monarchy in 1530 (illus. 9). Palissy perhaps had in mind the remarkable deep and transparent palette of Limosin enamels when he wrote that his knowledge of painting could help him to produce earthenware (*vaisseau de terre*). But instead of making images with lines and multiple mineral pigments, he turned towards the art of casting, a method practised by ancient and modern wax workers, goldsmiths and sculptors.

Casting from life mostly comprised taking imprints of the dead and giving them the appearance of the living. Uninterruptedly practised since antiquity, casting was used to produce funeral effigies and ex-votos. For Cennino Cennini (1370–*c*.1440), as he outlines in his *Libro dell'arte*, casting is one of the many techniques an accomplished artist was expected to master.[5] By the fifteenth century casting from life entered art history through the works of leading Florentine artists such as Ghiberti, Donatello

22 Della Robbia workshop, *Virgin and Child* (detail), 1487–8, glazed earthenware.

and Verrocchio. In the following century casting developed into a virtuoso goldsmith practice, recording and enhancing the finest details of delicate insects, herbs and flowers.[6] The basin of the goldsmith Wenzel Jamnitzer (1508–1585) dated around 1547–55 offers an example of the art against which Palissy measured himself (illus. 23). It includes casts of crayfish, frogs, turtles and snakes arranged in the manner of a time dial. Each section frames a frog and a crayfish – two frogs between four and six o'clock. Although these are repetitions of three identical casts, their placement belies their similarities. In the spirit of Mannerist sculpture the appearance of each animal looks different, depending on the position from which it is seen. Furthermore, while the basin was in use, snakes and frogs were partly immersed, with the lower part of their body animated by the random movements of water.

23 Wenzel Jamnitzer, rustic basin, *c.* 1547–55, gilded silver.

LOST AND DEATTRIBUTED WORKS

Over a period of four decades, Palissy directed three workshops
in Saintes, Paris and Sedan. Unfortunately, so little survives –
only ten authenticated pieces and many fragments – that it is
not possible to follow Palissy's career through his remaining
productions. The documents collected in Amico's monograph,
Bernard Palissy in Pursuit of Earthly Paradise (1996), and recently
augmented by new findings are merely indicative of payments
received, of Palissy's bad temper and conflictual domestic life.
None of his early works, paintings, stained glasses and maps have
either survived or been identified.

Palissy never signed his work. Perhaps he relied on the fame
he acquired through his unique style and inimitable technique to
establish his name without need of signature. If so he was wrong,
for his work was for a long time conflated with that of his fol-
lowers. Things have changed. The corpus of Palissy's works, best
described in earlier scholarship as a tentative selection from a mass
of tentative attributions, is currently reduced to no more than a
handful of pieces and many articles awaiting further scientific
scrutiny.

Attribution currently rests on three approaches: chemical,
biological and compositional. The chemical analysis of the Lyon
and Louvre rustic basins (illus. 37–9) has revealed the presence
of pigments and glazes absent in the production of Palissy's suc-
cessors. Glazes produce chromatic depth and luminous intensity;
they are fine transparent layers which light traverses before
bouncing back to the human eye. Painters such as Leonardo and
Titian were particularly fond of this technique. In painting, glazing
is easy: it is only a matter of waiting for each transparent coat to
dry before applying a new one. In enamel, however, glazing is
more difficult: nuances of colour, transparency and opacity depend
on the properties of a wide variety of minerals that melt at
different temperatures.[7] The complexity and multiplicity of

preparations Palissy devised and used still impress and puzzle modern curators; they testify to the mastery he acquired during his years of self-taught experimentation.[8] He was particularly proud of the thinness of his glazes, which never obstructed the delicate and complex skin textures of the cast animals – unlike the work of the Della Robbia workshop, the thick pastes of which he had criticized (illus. 22).[9]

Even if several rustic basins could be cast from the same mould (illus. 5), as was the case of the two kept in Lyon (illus. 38–9), their preparation was long and demanding. In comparison, the deattributed works were made with more straightforward techniques and processes, evocative of pragmatic professionals rather than of Palissy's work-intensive and time-consuming approach.

The pieces so far authenticated were either produced in Saintes or assembled from material prepared in the Saintes workshop that Palissy took with him when he moved to Paris in 1565–6. The fauna of the deattributed works comes from other

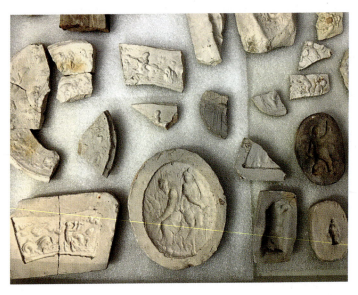

24 Fragments and rejects of medals from Palissy's workshop.

regions, some believed to be inaccessible to Palissy, and do not feature the chemical characteristics of the Saintes works.

In 1572 Palissy left Paris for Sedan, where he set up and ran a workshop, the production of which remains unidentified. By 1575 he was back in Paris offering public lectures and probably collaborating in the scene design and accessories of the court entertainments of the *Ballet des Polonais* (1573) and the *Balet comique de la Reine* (1581). Of these years, only excavated fragments survive, however, their variety hints at the activity of a bustling workshop. They include courtly accessories such as medals and plaquettes with portraits and mythological subjects (illus. 2, 24). Palissy had plenty of experience in this portable format, often worn sown on hats or cloths. He began producing enamel medals and plaquettes as early as the 1550s as a means of sustaining his family and financing his experiments in rustic wares and obviously continued once settled in Paris (illus. 25).[10]

25 Fragments and rejects of casts from Palissy's workshop.

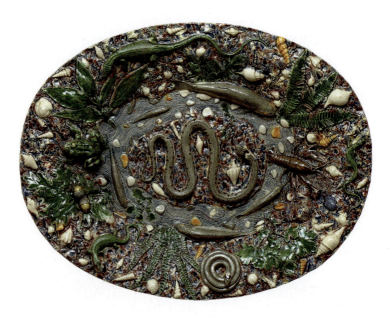

Casts of shells, insects, birds and mammals, including a rabbit, a crow, a seal and some pieces taken from human bodies probably relate to the grotto installations.[11] The inventories of Catherine de' Medici, drawn in 1589 shortly after her death, provide further clues of the amount of material lost. The section 'Vaisselle et Faïence' (crockery and earthenware) lists up to 141 pieces that could be connected to Palissy's productions.[12] Furthermore the inventory mentions 'Six fir wood boxes full of stones of various kinds to make rocks and fountains', suggesting that Palissy's modular ceramics could be used and reused as theatrical props without his personal intervention – as may have been the case in the *Ballet des Polonais* and the *Balet comique de la royne*.[13]

Deattributed pieces are now dated to the early seventeenth century. First among these are the rustic basins with island and snake, so emblematic of past conceptions of Palissy that his effigy holds one such object in the monumental statues that honour his memory in Paris and in Saintes (illus. 26, 55). In retrospect

26 Follower of Bernard Palissy, rustic plate, last quarter of the 16th century, lead-glazed earthenware.

it is now easy to observe that this format presents none of Palissy's *horror vacui* especially conspicuous in the Lyon and Louvre rustic basins and ewers, as well as in Palissy's written description of the Montmorency grotto, where he assures his reader that shells, vegetations and animals are disposed in such a way that 'nothing is empty.'[14] Furthermore, in the snake and island basins the evocation of water with undulated lines, a universal sign from prehistory to the highway code, is at odds with Palissy's sophisticated understanding of water as a fifth generative element better evoked in the blueish spotted enamel background of the authenticated works.

Another deattributed format are the bathtub sauce boats (illus. 28). These utensils featuring a couple or a single reclining

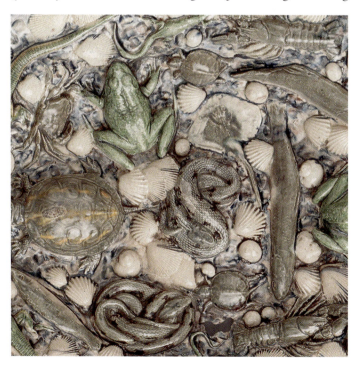

27 Bernard Palissy, Louvre rustic basin (detail from illus. 37).

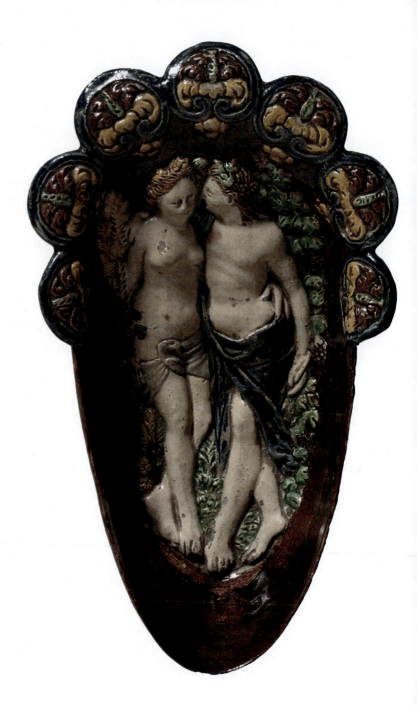

28 Follower of Bernard Palissy, sauce boat, *c.* 1580, lead-glazed earthenware.

female nude, sometimes personifying abundance and fertility, invite playful erotic associations between body, desire and flavour totally foreign to Palissy's interests and sensory orientations, which were attuned to the quest of knowledge rather than the pursuit of pleasure. Thus the recent tightening of Palissy's catalogue brings a stronger cohesion between his rustic production and his thought as much as it confirms their impact on the material culture of the princely table during the decades following his death.

AUTHENTICATED WORKS

Ewers

The core purpose of enamelling is to make surfaces waterproof, and the function of ewers is to hold perfumed water which is poured over the hands of banqueting guests and collected in basins with related decorations. It is nevertheless unclear whether Palissy's ewers ever served a practical or a merely decorative purpose. The current view that they are too fragile to be used can be contrasted against Palissy's proud affirmation that his enamelled terracotta is more solid than rock.[15]

Palissy probably produced many ewers and vases. The clerks who compiled Catherine de' Medici's inventory mentions altogether thirty vases.[16] Only three are left (illus. 29–33). The most basic of the three (illus. 29–30) could have been functional, but the other two (illus. 31–3) are indeed so impractical that they most likely served as theatrical props, fountain accessories or merely as self-standing demonstrations of Palissy's art. Regardless of their functionality, the blue ewers mirror three important aspects of Palissy's work and thought: first, his ideas on water as a generative and petrifying element; second, his views on the movement of the earth; and third, his belief on the formation and changing colours of minerals all represented in the jasperized

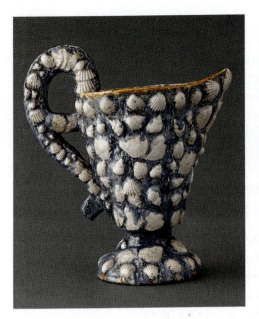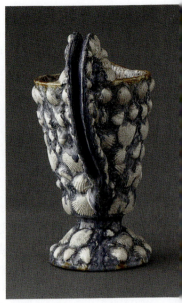

interior and in shells – white shells, the whiteness of which is the core element for the mastery of which Palissy drove himself to near exhaustion. In some cases, the white of the shells is the direct colour of the earth Palissy used.

Ewers and gilt basins decorated with subjects taken from fables and biblical, ancient or modern history were the pride of Renaissance goldsmiths. Their metal surface displayed an intricate aquatic iconography: mythological or historical compositions, sometimes even naval battles populated with personifications, ancient water deities Tritons, Naiads, Nereids set in seascapes or along rivers and framed with garlands of shells, fish, crabs and frogs. Palissy's ewers and basins are also representations of the water they contain – but in a literal rather than a mythological way. His earliest blue ewer, kept at the Musée du Louvre, the entry level of his production, illustrates his approach (illus. 29–30).

29, 30 Bernard Palissy, Louvre ewer with shells, *c.* 1550–60, glazed earthenware.

Blue is the standard and transcultural colour of water in most media, and so it is on these ewers, bluntly signalling that they contain water. Yet, faithful to the Renaissance's rhetorical ideal of variety and abundance, the blue ewer displays at least five species of shells of different sizes. In this painterly object, shells are shown submerged and emerging from blue water. They are arranged in an orderly fashion along the borders and the beak but deployed with more apparent randomness on the main surface as well as on the handle. The inside is jasperized, in imitation of precious marble, suggesting that this part was expected to be seen and set in optical movement by water.

The ewer with crayfish and frog (illus. 31–2) is not functional, since the lid does not open, suggesting that it could have been part of a fountain installation. The forward dynamic shape of the object itself is evocative of water gushing. If water ever flowed through it might have come out as a steady jet from the small mouth of the frog, and dripped along the sides bringing

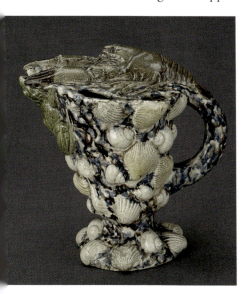
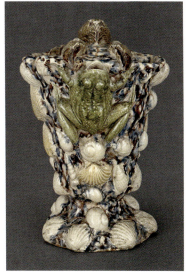

31, 32 Bernard Palissy, ewer with frog and crayfish, *c.* 1550–60, glazed earthenware.

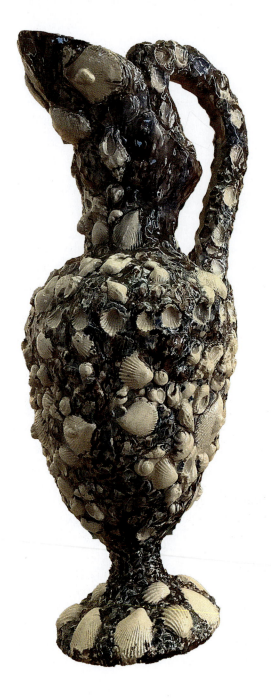

33 Bernard Palissy, Lyon ewer with shells, *c.* 1550–60, glazed earthenware.

further shine, like an ultimate glaze of real flowing water, over Palissy's blueish enamelled aquatic evocation.

The two Louvre ewers (illus. 29–32) share a similar shape and method of composition, as well as an arrangement of shells on their convex side. The Lyon ewer (illus. 33) displays an alternance of convex and concave shapes, with a row of concave shells on its centre.

Palissy has interpreted a Classical shape, a favourite format that inspired countless variations broadcast by prints after the designs of leading artists such as Raphael (1483–1520), Giulio Romano (1499–1546) and Francesco Salviati (1443–1478). These antique vases also embodied an ideal feminine proportion of neck, shoulder and bust analysed and detailed by the Florentine writer Agnolo Firenzuola (1493–1543) in his *Dialogo delle bellezze delle donne* of 1548, and applied to the idealization of female anatomy by Mannerist painters such as Parmigianino and Primaticcio.[17] In contrast to this Neoplatonic aesthetic of elegance and beauty, Palissy's treatment of the Classical form is crude and rugged. While these Italian Mannerist artists abstracted ideal forms from beautiful bodies and objects, Palissy went in the other direction, presenting the elegant shape of classical ewers, a favourite of Renaissance princely tables, as a natural formation of water and shells as if Nature was the artist.

The strong lighting under which this ewer is currently displayed at the Musée des Beaux-Arts de Lyon enhances its mineral character (illus. 33). The alternance of concave and convex shells, as well as the intensely reflective property of the ensemble, are evidence that this strange and spiky object was made to respond to light. This is one purpose of the arrangement of shells protruding on the surface or imprinted on the handle and the blue water-like background. The other is their brilliant white and multiple bevels, a means of catching and reflecting as much light as possible from as many angles as possible. This ewer

was perhaps intended as a theatrical prop; it would have suitably responded to the light-flooded setting of Valois court entertainments such as the *Balet comique de la royne* in which the sheen of ceramics inspired comparison with diamonds.[18]

Pilgrim flask

There is some irony in commissioning a pilgrim flask from a Calvinist artisan, since Calvinists considered pilgrimages to worship and pray to relics and miraculous images abominable superstitions. Pilgrim flasks are flat pear-shaped containers with two small hooks to be attached to a belt or a girdle. The earliest known flasks date from the Iron Age (*c.* 1600 BCE).[19] In Christianity, flasks often contained holy waters from pilgrimage sites and served both as souvenirs and talismans. By the

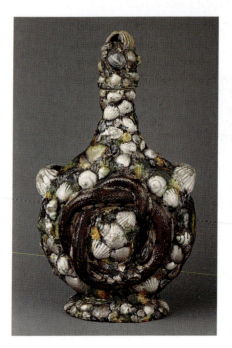
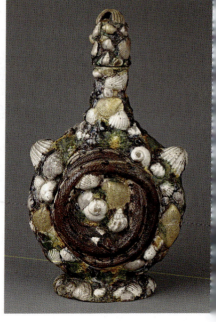

34, 35 Bernard Palissy, rustic pilgrim flask, *c.* 1556–67, earthenware with colourless and transparent or opaque pigmented green, purple, blue, yellow, red-brown and black lead glazes.

A PARIQVADRATA SVPERFICIE HVMĀI CORPORIS PERDISTINCTĀ EO NĀVRALI CENTRO
VMBILICI CIRCVLVM EXCIPERE: ET IN EO QVADRATVM MINOREM INSCRIBERE ▪ FIG⁴.

sixteenth century flasks had entered the category of luxury
objects sought after and appreciated for their precious material
and fine workmanship rather than their utility.

Decorations of pilgrim flasks feature ornaments, coats of arms,
emblems, images of saints or heraldic animals. Palissy's creation
is probably the earliest rustic interpretation of the genre. His
flask has two sides but neither front nor back, suggesting that it
was made to be seen from multiple angles, perhaps on a table, or
as a theatrical prop. Palissy has sampled the same fauna he used
for the Louvre ewer and the Lyon rustic basins (illus. 32, 38–9).

36 Vitruvian Man, from Vitruvius, *De Architectura*, ed. Cesare Cesariano
(Como, 1521).

It includes a freshwater grass snake, shells found on the French Atlantic coast (cockles, scallops, arks and Venus clams) and sea snails (whelks, moon snails and oyster drills). The flask bears resemblance to some grotto fragments kept at the Musée National de la Renaissance in Écouen and might have been created for this specific setting.[20]

One side of the flask displays a snake resting its head on its coiled body (illus. 34). The other side shows another, whose coil is arranged to evoke both a circle and a square (illus. 35). Neither snake bites their tail, excluding an allusion to the Ouroboros, a symbol of infinity. Perhaps in a rustic spirit, Palissy imagined the coil of snakes as natural geometric figures, thus echoing the circle and the square containing the Vitruvian man which for so long was emblematic of the Renaissance (illus. 36). Palissy knew well this figure as much as he disliked the ideal of universal proportions it exemplifies.[21]

The rustic basins

The three surviving rustic basins are the most complete and sophisticated works of Palissy to date. To the blueish ceramic base and shells of the ewers he has now added a colourful range of animals: frogs, lizards, snakes, turtles, fish and crayfish. The Louvre basin (illus. 37) is a variation on the composition formula of the Lyon basins (illus. 38–9): two lizards arranged along the borders with a small frog at the extremity. The two Lyon basins are based on the same master mould (illus. 5). Their small differences confirm that Palissy kept retouching his work until the last moment.

The imagery of goldsmith's basins and ewers displayed standard pictorial methods of representing space by means of geometric and atmospheric perspective, in playful rivalry with painting. There is no such fiction in Palissy's rustic basins; their scale is the same as the viewer's. The composition is balanced

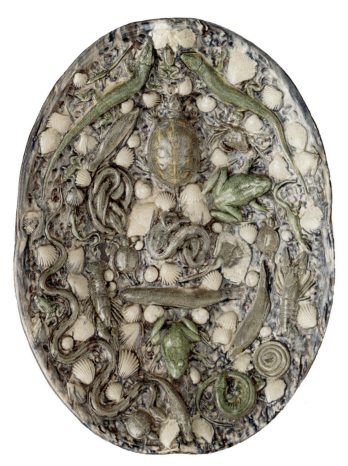

and roughly symmetrical, evocative of a market-stall display inviting the scrutiny of each individual animal. Like on a market stall, and in contrast with the traditional Renaissance perspective construction of space, the arrangement is such that each plate can be seen from at least four angles rather than from a single viewpoint. Furthermore, in contrast to the open pictorial space of mainstream Renaissance art, Palissy's world is one where nothing is left empty.

37 Bernard Palissy, Louvre rustic basin, *c.* 1550–60, glazed earthenware.

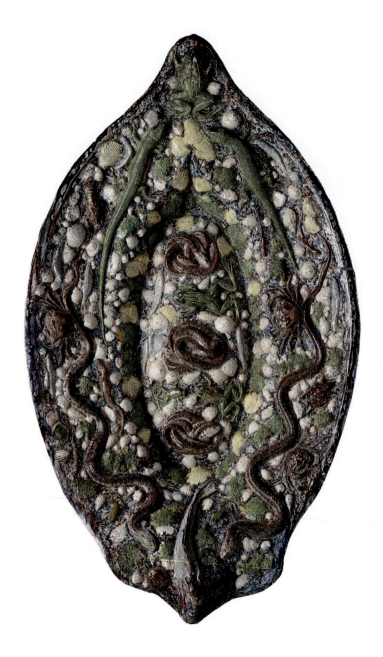

38 Bernard Palissy, Lyon rustic basin, *c.* 1550–60, glazed earthenware.

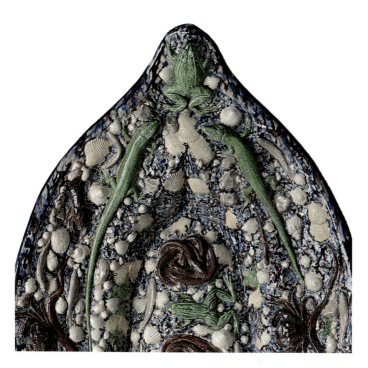

For Palissy the complexity of the patterned skin of lizards, snakes and frogs and their striking colours are tangible evidence of the refined artistry of nature. The many medical and pharmaceutical properties of lizards feature often in early modern recipe books but not in Palissy's writings.[22] The finely cast lizards and snakes of the Lyon and Louvre basins confirm the pride with which he asserted, in the *Ordonnance de la grotte*, that he has recorded every single scale of each animal better than any painter could have.[23] Without this explicit virtuosity the basins are implausible displays of familiar animals that could never have met alive, since they breed and live in different environments.[24] Such unnaturalistic arrangements did not bother Palissy, who, in his grotto projects, also mixed fresh-water and sea-water dwellers, some alive, some cast and enamelled.[25]

39 Bernard Palissy, Lyon rustic basin, *c.* 1550–60, glazed earthenware.

One passage of the *Discours admirables* highlights what Palissy had in mind when working on these unusual objects. He describes how, under the action of the sun 'claunes', small ditches for collecting rainwater generate an aquatic fauna comparable to that of the rustic basins:

> In truth, such waters cannot be good for men or beasts. Because they are heated by the air and by the sun, and by this means engender and produce several species of animals and especially since there is always a large number of frogs, snakes, aspics and vipers staying close to the said ditches in order to feast on the frogs.[26]

This fauna basking in poisonous water may have conveyed some form of disgust, just as Palissy basins still do with many present-day viewers, as I could observe showing these works to generations of graduate students. In fact, the association of stagnant water with frogs also features in the works of another Huguenot, Jean de Léry (1536–1613), in his account of his travels to Brazil. There he describes the greenish liquid he drank from a rain reservoir, 'as green, dirty and disgusting as an old ditch covered with frogs'.[27] In the context of their time, the rustic basins may have also inspired this particular kind of pleasure which, according to Aristotle (384–322 BC), we take in seeing representations of things which would inspire in us discomfort in reality.[28] In all likelihood, the water that circulated in these glazed objects was fresh, either perfumed or potable, pleasantly deceiving olfactory expectations of its sight. Regardless of this sensory twist between sight and smell, the rustic basins coincide with Palissy's conception of water as generative of mineral and animal life. With the ewers and fragments, they provide partial yet concrete evidence of the emphasis on colour, shine, tactile smoothness and crisp naturalism that is characteristic of Palissy's accounts

of his grotto projects where he extended his repertoire to birds, mammals and humans.

Grottoes

Palissy described his grotto projects in his two first publications: the *Architecture et ordonnance de la grotte rustique*, a short dialogue on the installation commissioned by Anne de Montmorency, and the *Recepte véritable*. There, extending his artistry from tableware to the natural world, he expounds his philosophy of agriculture and proposes a garden ensemble of grottoes and fountains that could, in his own words, benefit 4,000 French aristocratic estates.

Palissy prepared at least three grottoes, the first for Montmorency and the other two for the queen mother, Catherine de' Medici. The Montmorency grotto, of which he published a detailed account in 1563, has never been identified but since he received payment something was delivered or at least seen to be in progress.[29] The fragments found in Palissy's workshop are currently kept at Écouen castle, acquired and renovated by Montmorency to receive French and foreign royalty, but its park and surroundings bear no trace of any artificial grotto.

The second grotto commissioned by Catherine de' Medici for the Tuileries gardens, and mentioned in several diplomatic correspondences, was damaged beyond repair in 1589.[30] Palissy may have recycled material from the Montmorency project, a hypothesis corroborated by fragments excavated during the construction of the Louvre Pyramid, which are based on material prepared in Saintes – that is, at the time of the Montmorency commission (illus. 2, 40).[31] Installations very similar to Palissy's grotto descriptions also feature as part of the theatrical set of two court entertainments, the *Ballet des Polonais* and the *Balet comique de la royne*, the libretto of which mentions a grotto specifically erected for the occasion to represent the empire of the earth god Pan.[32] Palissy was in Paris at the time, overseeing the printing of

40 Bernard Palissy, grotto fragment, *c.* 1560, glazed earthenware.

his *Discours admirables*, on the title page of which he still holds the moniker 'inventeur des rustiques figulines du Roy et de la Royne sa mere', so there is every good reason, in spite of his silence, to assume that his work was used – especially since the *Balet comique* was commissioned by the queen mother. Comparing the libretto's detailed account along with Palissy's own writings and remaining ceramics highlights the gaps and overlaps between his intentions and the use and reception of his work, as we will see in the next chapter.

The Montmorency grotto is the only one that Palissy describes as completed. It measured 16 × 6 metres (52 × 20 ft), was about 3.5 metres (11 ft) high and received natural light from an undisclosed number of windows separated by terms or ornamental columns.[33] The *Recepte véritable* develops this first project into an ideal garden located on a hill where nearby streams irrigate eight cabinets or artificial grottoes located on the four corners of its square plan, to serve as study, meeting rooms and even storage rooms.[34]

In each grotto, flowing water enhances the shine of Palissy's enamelled animals and sustains the optical illusion of movement. The fauna of the Louvre and Lyon basins (illus. 37–9) has multiplied in the Montmorency grotto, as well as with those of the *Recepte véritable*:

> On the edge of the [...] ditch there is a terrace, on which are imprinted an infinite number of aquatic animals, such as turtles, crayfish, crabs, frogs, spider crabs, mullets, pikes, dogfish and other species of rare and strange fish. All of the aforementioned species of fish throw water through their mouths, into the ditch, which is below the said terrace, in such a way that when the said ditch is full, the superfluity of the water disgorges through a secret channel and turns into a large garden, which is in front of the said

41 Frontispiece of Hughes Sambin, *Oeuvre de la diversité des termes* (Lyon, 1572).

grotto. You must here note that this great number of
water spurts which fall from the mouth of the fish, causes
the water in the ditch to move, so that the fish is lost from
sight at intervals, because of the movement of water and
certain circulations which the said spurts cause, so that
it seems that the fish is moving in the ditch.[35]

The grotto projects confirm that Palissy used flowing water to
animate his figures, literally using water to represent his belief
in its life-generating power. The rustic basins connect Palissy
to goldsmith work and maiolica, but the genre of the grotto also
stands at the confluence of the most influential ornamental
tradition of the time, the *grottesche*.

In the Renaissance, the word 'grotto' also connects with
grottesche, a decorative imagery derived and expanded from the
frescoes rediscovered in the 1470s in the Domus Aurea, Emperor
Nero's former Roman palace. Since the Domus was buried under
the ground, it was considered a grotto and its decorations were
called by extension *grottesche*. This style of ornamentation filled
with hybrid combinations of human, animal, vegetal and mineral
elements promptly spread from the vaults of the underground
imperial palace to the repertoire of the painters active in Rome
at the time before reaching the rest of Europe thanks to printing
media.[36]

Two elements of Palissy's grottoes, absent from the rustic basins,
engage with this trend and extend his repertoire to the human
form: the *hommeaux* and the terms. Architectural terms are the
application of the playful combinatory spirit of *grottesche* to orna-
mental columns framing windows and doors. The genre was
popular enough to inspire the cabinet maker Hugues Sambin
(1520–1609) to publish an anthology in 1572, where geometric,
vegetal, floral and animal forms are blooming into human figures
(illus. 41).[37] Palissy's terms fit neatly into this tradition. In particular,

the three surviving examples illustrate a natural process of rock and fossil formation leading to what Palissy designates as 'the geometry of the human form' (illus. 42).[38] These terms have also inspired associations with the well-known portrait still-lifes of Arcimboldo (1526–1593), especially since their common breeding ground is Renaissance festive culture (illus. 43). Arcimboldo's elemental fantasies, however, are still-lifes with optical illusion, unlike Palissy's terms, which represent his geological belief in a long and deep process of rock formation that begins with water

42 Inverted photograph of Bernard Palissy, cast for architectural term, *c.* 1570, plaster.

and slowly and naturally morphs towards the appearance of the human figure.

Palissy's treatment of the *hommeaux* expands the idea of the human form as a natural extension of mineral and animal life. Unlike terms, the function of which is mainly ornamental, the *hommeaux* are structural since they provide the fences, columns and roofs of some of the grottoes of the *Recepte véritable*. The word *hommeaux*, usually translated as 'elm trees', literally means 'little

43 Giuseppe Arcimboldo, *Emperor Rudolph II as Vertumnus*, c. 1590, oil on panel.

men'. In Palissy's parlance, *hommeaux* are trees grown as columns
with human shape. He concocted this idea by conflating two
passages of Vitruvius' *De Architectura* – the only surviving architec-
tural treatise from Classical antiquity – stating that tree trunks
were the first building blocks of primitive architecture and that
columns resemble the physical features and ideal proportions
of Greco-Roman anthropomorphic divinities.[39] In the *Recepte
véritable*, Palissy quotes Vitruvius on the temple of Diana, stating
that the grooves of the columns represent the folds of the god-
dess's cloth and their ornate capitals the elaborate locks of her
headdress.[40] From these passages Palissy extrapolated that stone
columns are based on those made of wood, the mother of all
columns, and that the true origin of the column is the human
body:

> you know that a portrait which will have been counter-
> feited following the example of another portrait which
> will have been made, will never be so esteemed as the ori-
> ginal, on which the portrait will have been taken. This is
> why columns of stone cannot be glorified against those of
> wood . . . especially since those of wood have engendered
> or at least shown the means to make those of stone.[41]

From this he resolved that he could give trees a human shape
through various incisions promoting the growth of the trunk
and branches into architectural elements:

> And as for the present hommeaux, which will be the
> fence and roof of the said cabinet, they will be put and
> erect in such an order, that the legs of the hommeaux will
> serve as columns, the branches will be architrave, frieze
> and cornice and tympanum and frontispiece.[42]

Not only did Palissy impose classical architectural shapes on
trees, but he intended to grow their branches in the shape of letters
enunciating biblical quotations, thus turning trees into the man-
uscripts rather than the book of nature. He may have developed
this idea from the practice of casting where the flexible and linear
body of lizards and snakes is set into elegant curvatures by means
of pins and needles.[43] Medieval and early modern scholars imagined
Nature as the book written by their god, yet the idea of arranging
branches in the form of letters so that they appear to have grown
naturally, composed via nature by a divine mind, is unusual.[44] The
late antique Neoplatonic philosopher Plotinus (d. AD 270) believed
that stars are moving letters.[45] In Palissy's time the polymath,
prophet and Christian Kabbalist Guillaume Postel (1510–1581)
held the view that the disposition of the stars follows the shape
of Hebrew letters, and that deciphering them reveals the future.[46]
Palissy most probably knew about Postel through his friend François
Choisnin, who belonged to the circle of the prophet and visionary.[47]
Their apparently unconnected parallel beliefs, however, enhance
Palissy's intensely earthly orientation as he makes the fruits of the
soil speak a language that others sought and read in the sky.

Asked about the care and durability of his *hommeaux*, he assures
that they should last at least the life of two humans and require
only minimum maintenance.[48] Letters would have surely necessi-
tated much more care and regular trimming at the risk of growing
out of their initial meaning.

Palissy devoted much attention to colour, which he understood
as a core attribute of life and movement rather than as the out-
come of a perceptual phenomenon.[49] As a ceramist he spent years
figuring out how to obtain and control specific colours and trans-
parencies; as a natural philosopher he scrutinized the random
forms, shades, veins and hues of gems, precious marbles and
figured woods such as mahogany, walnut or flamed maple.[50] One
of the first commercial steps in his pursuits of enamels was the

production of jasperized plates, ceramic renditions of the veining
of precious marbles, which apparently sold well enough to feed
his family and finance his more ambitious plans.[51] These successes
probably led him to think that he could expand this technique
from plates, cups and ewers to entire rooms. In the *Recepte véritable*
he anticipates smearing the inner walls of each grotto with an
enamel preparation of crushed glass and minerals. He would then
light a fire in the centre of the room to melt the enamels along
the walls. 'And thus,' he writes, 'the enamels by liquefying, will
flow, and by flowing will intermingle, and by intermingling will
make very pleasant figures and ideas (*ydees*).'[52] He thought he could
produce these random figures, observed in precious marbles and
ornamental woods, through an accelerated re-enactment of their
natural process of formation.[53]

In the same spirit, as he mixed real and cast animals, he inserted
genuine gemstones and fragments in the enamel rock structure
of the projected grottoes.[54] This way he set the natural luminosity
of gems against the intense shine of his enamel. His techniques
attended to the pleasure of the eye by generating random com-
binations of colours on intensely reflective surfaces 'shiny and
pleasant', even on the seats and tables, 'enriched and coloured
with various enamel colours which will shine like a crystalline
lens'.[55]

Palissy's installations addressed sight as much as hearing, touch
and olfaction. The enamel pleases the eye with gleaming colours;
it also produces resonant acoustic, ambient freshness and tactile
smoothness. The walls are so smooth that even real lizards, says
Palissy, cannot climb. Furthermore, the trees grown outside each
grotto will produce not only letters of divinely inspired words
but sweet-scenting flowers and berries, ensuring the continuous
attendance of chirping birds whose song will accompany the
gurgle of flowing water and the whispers of wind whistles for a
continuous yet varied sonic background.

Present-day ceramists and curators have confirmed the impossibility of turning a large room into a kiln and holding its temperature at around 1200°C (2190 °F) for several hours. Palissy's thinking, like that of Leonardo, is based on the belief that what can be done on a small scale can merely be repeated on a larger scale. This macrocosm/microcosm approach is also key to understanding the exponential growth of Palissy's projects, from producing plates, vases and basins to installations of grottoes, fountains and gardens.

44 Rock of the Muses, from Jean Dorat, *Magnificentissimi spectaculi a regina regum matre in hortis suburbani editi* (Paris, 1573).

THREE

Reception

he Montmorency grotto was never identified. Some scholars doubt that it was ever built, and others suspect that Palissy recycled the material he prepared for Montmorency in the Tuileries garden grotto. The grottoes of the *Recepte véritable* are only projects and the later autobiographical chapter of the *Discours admirables* refers only to the rustic basins. Yet by 1566 Palissy was in Paris serving Catherine de' Medici. Evidence for the grotto and fountains commissioned by the queen mother for the Tuileries gardens comes from documents stating that Palissy and his two sons, Mathurin and Nicolas, received payment for their work in 1570.[1] Descriptions of court entertainments and ambassadorial visits dating from 1573, 1575 and 1581 confirm the presence, use and reception of Palissy's works.

THE *BALLET DES POLONAIS*

The first testimony comes from the printed and illustrated account of the festivities organized for the reception of Polish ambassadors on 19 August 1573 to celebrate the presentation of the Polish crown to the future Henry III (illus. 44). On this occasion an artificial silver-gilt rock was erected with a set of eighteen grottoes, each featuring a nymph personifying a French province. The nymphs were played by members of the court. Brought to centre stage on their rock by six strong men, they

sang verses composed for the occasion by the court poet Pierre de Ronsard in front of the royal family and their guests. After about an hour of singing the rock was moved back to its corner. One of several ballets began.

The description of the rock, in the libretto of the event composed by the poet Jean Dorat (1508–1588), is evocative of Palissy's installations swarming with shells and animal life for it features 'a thousand shells and a thousand figures wonderfully painted in various artful colours'.[2] The engraving is not particularly detailed but nevertheless reveals the presence of some lizards, snails and snakes on the lower right-hand side (illus. 44). Furthermore, the human figures and faces embedded in the arches framing each nymph resemble Palissy's terms and *hommeaux*. In Dorat's text, the attention to such minute details as lizards, snakes and shells in such a monumental ensemble implies a particular awareness of the remarkable products of Palissy's kilns – although his name is not mentioned. The *Ballet* took place in 1573, suggesting that the Tuileries workshop remained active and that Palissy may have occasionally commuted between Paris and Sedan.[3] Or perhaps he had produced enough material to be reused in his absence, as evidenced by the six wooden boxes of Palissean material mentioned in Catherine de' Medici's inventory.[4]

Two years later, a delegation of Swiss ambassadors received by Henry III and the queen mother visited the Tuileries gardens. They report seeing a labyrinth, some rustic furniture and praised the impressive variety of trees of the garden. They also describe a fountain and a grotto very similar to the installations projected in the *Recepte véritable*:

> there was a fountain constructed like a rock, in which rock, from the work of pottery, were carved various animals, such as snakes, snails, lizards, crabs, frogs, and all kinds of aquatic animals. These animals poured water from their

mouths, but the rock itself seemed to ooze water. These
were prepared at great expense and with wonderful art,
but now, because no one takes care of these, they run the
risk of falling in ruin.[5]

The last sentence has generally been taken as evidence that by
1575 the Tuileries grotto installation was already falling apart
through lack of maintenance. This assumption is, however, at
odds with Palissy's belief in the solidity of his enamel as much as
with the formal spirit of ambassadorial receptions, always chore-
ographed to impress guests. Henry III spared no expense in festive
and official occasions and was himself obsessed with matters of
the ceremonial.[6] He is unlikely to have shown a broken-down
neglected part of his estate to visiting diplomats. It might just be
that the Swiss dignitaries were fooled by Palissy's rustic creations
of raw and rough rock formations, 'as if they had been shaped
with big hammer blows' and mistook his representation of the
damage of time for the real thing.[7]

At the time of the Swiss ambassadors' visit to the Tuileries
gardens, Palissy was back in Paris, where he had just delivered his
public lectures (that were published five years later as the *Discours
admirables*). It has been hypothesized that from the mid-1570s on-
wards he devoted his time to research on natural history. Yet in
1581 another grotto installation and some rocks and casts bearing
his naturalistic signature feature in the most spectacular and
lavish court entertainment of the time.

THE *BALET COMIQUE DE LA ROYNE*

Performed on 15 October 1581 in the Great Hall of the Hotel
du Petit-Bourbon (a palace demolished in the eighteenth cen-
tury that was located on the rue d'Autriche on the right bank
of the Seine, near the Louvre), the *Balet comique de la royne* was

commissioned by the queen mother. It concluded two weeks of
races, equestrian displays, tournaments, banquets and balls cele-
brating the marriage of Marguerite de Lorraine-Vaudémont to
the Duc de Joyeuse.[8] The wedding and its multiple celebrations
were intended to unite the French nobility around the king. The
excessive expenses shocked many. About 10,000 ecus (roughly
£2.5 million) went to the cloths embroidered with gold and
silver thread, diamonds, gems and pearls worn by the king, the
bridegroom and their entourage.[9] Pierre de l'Estoile estimated
the total cost at more than 1,200,000 ecus (*douze cens mille écus*),
and the historian Nicolas Leroux recently observed that in 1595
some jewellers were still claiming 65,133 ecus, which represented
only one third of the entire merchandise they had supplied.[10] This
financial assessment broadly concurs with the plethora of pre-
cious material rapturously described in the printed and illustrated
record of the *Balet comique*.

Balthasar de Beaujoyeulx (d. 1587), a musician, poet and
Valet de chambre de la reine, masterminded the *Balet comique* with the
assistance of Nicolas Filleul de la Chesnaye (1530–1575) for the
text, Girard de Beaulieu (d. c. 1587) for the music and the painter
Jacques Patin (1532–1587) for the scene design, as well as a cohort
of unnamed artisans which most likely included Palissy and his
sons. The theme is the deliverance of France from the grip of
the enchantress Circe, a mythological figure of blind desire, who
seduces men and transforms them into animals.

The first illustration of the libretto depicts the beginning of
the play when a gentleman, who has escaped the garden of the
enchantress, begs the king to free the world from her evil power
(illus. 45). The booklet concludes with allegorical interpretations
of the play by members of the court, emphasizing the heroic role
of the king in saving the world from Circe's evil empire of insa-
tiable desire. Members of the audience were especially impressed
by the choreography of the Naiads, in which the dancers formed

forty geometric figures, each punctuated by a pause, thus conveying, by means of movement and geometric proportions, the illusion of France as a harmonious kingdom.[11]

The print provides limited information, but the text is detailed and eloquent (illus. 45). Facing the king and queen and their entourage, shown from the back, is Circe's garden and the fountain of the Naiads on the left. On the right is the grotto of the god Pan and on the left a montage of artificial clouds and stars from which Jupiter and Mercury will later access the stage. This set has been interpreted as a representation of the universe with its four constituent elements: air (the starry sky); earth (Pan's grotto); water (the Naiads' fountain); and fire (Circe).[12] The action takes place in this cosmos and the text is sufficiently detailed to allow us to distinguish the contribution of Palissy's workshop.

Circe's garden is artificial, meaning that everything is made by art, rather than by nature. Beaujoyeulx lists an abundance of herbs, fruits and vegetables very close to the repertory listed by Palissy himself in the *Architecture et ordonnance de la grotte* and adds that everything is fake. A pergola frames Circe's garden 'from all sides of which one saw some big and beautiful grapes, made with so much art that even the most discerning [spectators] took them for real, and nature herself seemed to be astonished by this artifice'.[13]

These artificial fruits might have been baked in Palissy's kilns, as suggested by some fragments as much as by his pride in the crisp sharpness of his ceramic fruits, batrachians and reptiles.[14] Palissy's art is most conspicuous in the grotto of Pan in particular for the way it reflects light. Let's hear Beaujoyeulx: 'I had a grotto set up as dark as the depth of some deep rock, which shone and was lit outside as if an infinite number of diamonds had been applied to it.'[15]

Similar diamond-like sparks feature in two passages of the *Recepte véritable*. Palissy explains that he has selected real stones

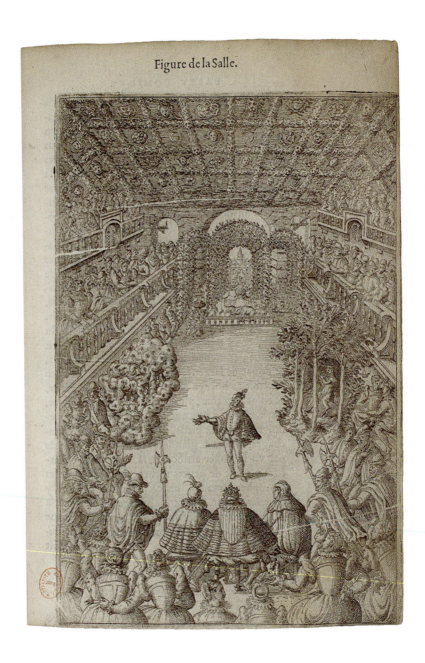

45 Baltasar de Beaujoyeulx, *Le balet comique de la royne* (Paris, 1582), main stage.

– for their colour, reflectivity and silvery sparkles – to implant
in his fabricated rock as a background for his enamelled animals.[16]
The artificial vegetation and fauna framing Pan's grotto also bear
Palissy's naturalistic signature, 'decorated with trees and covered
with flowers, among which we could see some lizards and other
animals so accurately represented that one would have thought
they are alive and natural'.[17]

Beaujoyeulx gave much attention to lighting. The trees are
laden with golden oil lamps in the shape of boats.[18] On the left-
hand side of the print, the clouds and stars conceal a wooden vault,
entirely gilt (illus. 45). This golden vault holds a small orchestra

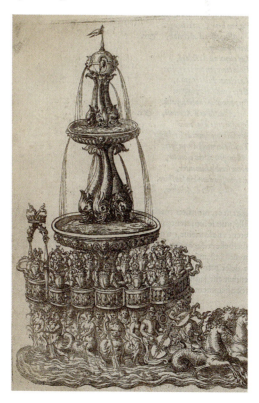

46 Baltasar de Beaujoyeulx, *Le balet comique de la royne* (Paris, 1581), fountain of the
Naiads.

and is so brightly lit that its radiance illuminates and traverses the clouds through which Jupiter and Mercury later enter the scene. Circe's garden is also filled with light. On the main portal of her castle is a vault shaped like a garfish (*aiguille de mer*), studded with holes covered by glasses of all colours behind which were as many oil lamps. This combination of organic forms and stained-glass know-how, reminiscent of one of Palissy's first professions, is another hint of the contribution of his workshop, located only a few hundred metres away from the hall where the *Balet* itself was performed. Apart from the lighting of each part of the scene, Beaujoyeulx adds that: 'the infinite number of torches placed above and all around the hall, gave so much light as to shame the most beautiful and serene day of the year.'[19] The intense light produced by torches and oil lamps triggers and enhances the luminous aura of the innumerable gems worn by the king and his entourage, as well as the many gilded theatrical props of the *Balet comique*. Everything shines, reflects, flickers and moves, even geometric forms.

In Circe's garden much is gold, silver and silk.[20] The sirens, whose song opens the second act, wear tails of gold scales and burnished silver while their hair is mixed with gold thread down to their waist. The fountain of the Naiads moves to centre stage in the third act (illus. 46). It rests on a sea of burnished silver inhabited by tritons of burnished gold; the upper basins filled with scented water are gold and silver. The Naiads impersonated by the queen mother herself and her immediate entourage occupy the main balcony. The print does not show much but the text insists that they wear silver fabric laced with gold and their head holds diamonds, rubies, pearls, and other 'exquisite and precious gems'. Necklaces and bracelets enhance their neck and arms and their clothes are studded with gems which 'shone and sparkle like when at night we see the stars against the dark blue robe of the sky'.[21] In the *Balet comique* the diamond-like glow of Palissy's

47 Bernard Palissy, Lyon ewer with shells (detail from illus. 33).

artificial rocks, fruits, lizards, snakes and shells is in dialogue
with the luminous auras of real diamonds, gems, silver and gold
described by Beaujoyeulx (illus. 47).

RENAISSANCE TASTE

The idea of placing side by side works produced with consid-
erable ingeniousness in inexpensive material and objects made
of gold, silver and gems is typical of Renaissance elite taste. The
Florentine humanist Leon Battista Alberti (1404–1472) in his
De Pictura (1435) set the tone when he wrote that painters would
earn more praise by representing gold than by applying gold leaf
to their panels. A century later Giorgio Vasari (1511–1574) con-
veyed the very same idea in his biography of Cosimo Rosselli
(1439–1507), in which he recounts how an astute journeyman
concealed his mediocrity with an abundance of gold leaf and
shiny ornaments to secure the favours of Pope Borgia by flatter-
ing his bad Iberian taste for everything shiny.[22] Things have not
changed that much: good taste is about appreciating creativity
and artistry, bad taste is about being blinded by bling.

By the sixteenth century the appreciation of artworks had
developed in the intimate atmosphere of private collections, in
churches and chapels as well as on the tables and dressers, or
credenzas, of the powerful. Palissy probably used a type of furniture
like a dresser to exhibit his collection of minerals, fossils and
shells in support of his ideas. Princely dressers feature in about
every early modern image of banquet. Instead of geological sam-
ples they displayed historiated cups, maiolica plates, gilded ewers
and basins enriched with gems as well as objects of lesser material
value but of equally inventive workmanship (illus. 48). While
ewers, basins, plates and serviettes were used during a banquet,
dressers also held objects meant only to be seen and appreciated
for their artfulness. One example is the elaborate folding of

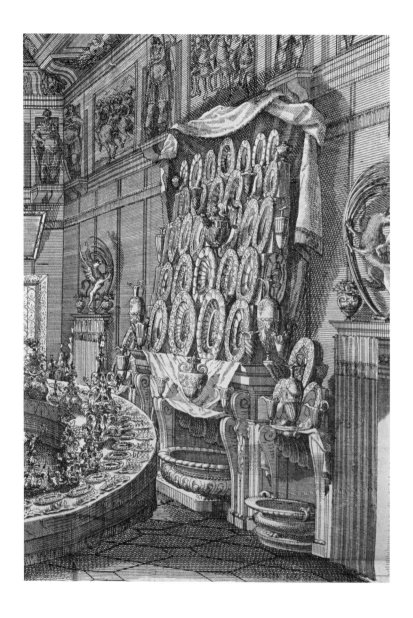

48 Detail of dresser from the frontispiece of *Disegni del convito fatto dall'illustrissimo signor senatore Francesco Ratta* (Bologna, 1693).

napkins and tablecloths into images of mammals, birds and drag-
ons, heraldic emblems, towers and castles; entities of folds, light
and shade.[23] The pleasure of the eye is also the unique purpose of
the Saint Porchaire ceramics too fragile for any practical use, often
associated with Palissy, because of their place of origin, their deep
luminous whiteness and elaborate imitation of goldsmith work
(illus. 3).[24]

For Montmorency, Palissy's work was more than mere dec-
oration, it was an avant-garde sample of the rustic style.[25] This
minor genre reached a peak in the years 1515–18 at the Roman
villa of the banker Agostino Chigi, which Raphael and his assis-
tants decorated. The garlands and trellises painted by Giovanni
da Udine (1487–1564) around each episode of the story of
Cupid and Psyche form a vegetal encyclopaedia displaying some
typical rustic joke, such as the evocative juxtaposition of a large
phallic squash and a fig – in Italian a punning allusion to female
genitalia. The connétable probably feasted under these frescoes
during one of his stays in Rome. Many vegetal ornaments of
Écouen castle ooze with such rustic spirit and the story of Cupid
and Psyche enlivens the stained-glass windows of the gallery of
its west wing.

Although Palissy's core discipline – agriculture – traditionally
deals with the fertility of plants and animals, he was a prudish
man, who once even requested a woman to cover herself.[26] There
is not much about sex and pleasure in his writings, and the only
allusion to a penis is that of a fox exposing his organ as a bait to
catch imprudent birds.[27] Yet his understanding of the earth as
the living matrix of the world bestows the appearance of female
organs on his surviving rustic basins.[28] This aspect comes to the
fore when photographic reproductions of the basins are printed
in portrait rather than in landscape format. At the top end the
addition of a small frog, one to jump at the lightest touch, seems
a rustic allusion to clitoridean sensitivity (illus. 38, 39, 49). That

Palissy's work might have been made and perceived in terms of fertile femininity rather than phallic masculinity, and amused his patrons, is also hinted by the Lyon ewer studded with shells (illus. 33, 47), understood as allusive of female genitalia since the time of ancient Greek comedy.[29] Similarly the shape, scent and fertility of flowers depicted in floral albums, such as those attributed to the circle of the Huguenot draftsman Jacque Lemoyne de Morgues (*c.* 1533–1588) which circulated in French elite circles, frequently inspired allusions to the vulva.[30]

Catherine de' Medici, who employed Palissy from 1566 until her death in 1589, certainly picked up this gendered aspect of his production. Enhanced by real water, a traditionally female element, Palissy's wares were eminently compatible with the themes of nature and fertility omnipresent in the many royal entries and court entertainments devised by the queen mother and her advisers, frequently associating her with ancient goddesses of fecundity and abundance.[31] The inventories of her goods record the presence of ceramic plates and basins by Palissy, but she also employed him for more monumental assignments: the Tuileries

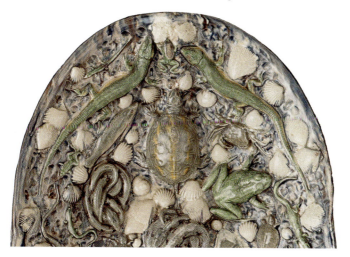

49 Bernard Palissy, Louvre rustic basin (detail from illus. 37).

grotto and fountain as well as the theatrical sets of the *Ballet des Polonais* and the *Balet comique de la royne*.[32] In these, the work of Palissy represented both the lowest and highest strata of the fictive Platonic Pythagorean cosmos of late Renaissance court entertainments: the hyper-naturalism of the ceramic casts embodied the sublunar world of nature and matter while their extreme reflectivity generated the ethereal attributes of divine light.

WORLD VIEWS

The philosophies of the queen mother and her courtly entourage have been the subject of extensive and detailed studies.[33] For the French courtly circles, the universe was composed of hierarchical layers ascending from the earthly material world to the ethereal spheres of the seven planets of pre-modern astrology (illus. 50). The planets influence the course of natural history and human actions; their harmony and energy can be apprehended and channelled thanks to the multiple resources of music, astrology and magic, while humans can themselves ascend to divinity through the power of their own mind. One famous manifesto of this world view is the *Oration on the Dignity of Man* (1486) by Giovanni Pico della Mirandola (1463–1494), which places humans at the centre of the universe between angels and beasts, endowed with the potential to descend to the animal condition or ascend to angelic spirituality.[34]

One way to rise up to the divine is via the senses of sight and hearing, which Renaissance Neoplatonism privileged over the lower senses of taste and touch activated by physical contact. The former are spiritual senses, receptors of incorporeal manifestations and of celestial attributes such as harmony, grace and beauty, the first steps of the ascension of the soul to the contemplation of God. Appreciation of the incorporeal objects of sight is conspicuous in the mundane Platonism of Renaissance love literature; it

left its imprint on the appreciation of art, and it partly informs the appreciation of dancing, a central activity of the Valois court. Balls traditionally took place after banquets. Those participating were expected not only to master the steps and timing of each dance but to execute them with 'grace and majesty', two incorporeal qualities particularly appreciated by Platonists and Platonic lovers, since they express spiritual rather than physical attributes.[35] Balthasar de Beaujoyeulx, the mastermind of the *Balet comique de la royne*, went further in stimulating the intellectual potential of sight with a choreography in which groups of dancers recreated the shape of forty moving geometric figures. Thus the audience could shift from the corporeal to the incorporeal, that is, from the perception of human bodies to the perception of geometric forms considered expressive of divine proportions and harmony.

Spiritual delight in the impalpable objects of the visual field also stimulated attention to the phenomena of light. The influential Neoplatonic philosopher Marsilio Ficino (1443–1499) composed an entire treatise on the subject, *De Lumine* (1493). Brushing aside centuries of discussions on the materiality of light, Ficino asserted the incorporeality of light, for 'it originates from a light higher than bodies, clearer, and immeasurably greater'.[36] A century later, Palissy's contemporary the philosopher Giordano Bruno, in his *De Umbris idearum* (1582) dedicated to Henry III, reiterated the same idea that light is the intelligible shadow of God.

Using and manipulating light to make it appear like a visible manifestation of divinity is at the heart of the public dress code of the Valois kings. The myth of the solar king, appropriated in the seventeenth century by Louis XIV, was already in place one hundred years earlier.[37] To quote historian Luisa Capodieci, the luminous costume of Henry III literally makes him a star, 'which radiates its beneficial power on its subjects. Shimmering fabrics, gold, silver, polychrome stones make manifest by their brilliance its active power and give visibility to its divine nature.'[38]

50 Franchinus Gaffurius, Harmony of the Spheres, from *Practica musicae* (Milan, 1496).

The *Balet comique de la royne* participates in the same Platonic sensorium. While banquets are expected to engage all the senses, court entertainments address only sight and hearing as well as understanding, as confirmed by Beaujoyeulx's slightly self-congratulatory unpaginated address to his reader: 'I can say that I satisfied in a well-proportioned body the eye, the ear and the understanding.'[39]

A central aspect of this optical gratification is the extreme intensity of light produced by torches and oil lamps, a true health and safety officer's nightmare, devised to enhance the luminous aura of the innumerable gems worn by the king and his close entourage. This is the glow to which Palissy's gleaming ceramics contributed – representing both the finest material details of the lowest spheres of the world and the highest perceptible manifestation of the divine: light. This theatrical context also meant that Palissy's installations of artificial rocks, plants and animals, initially conceived as multisensory environments, were reduced to luminous optical entities.

Palissy's dream garden of the *Recepte véritable* has been associated with an evocation of Paradise developed from Psalm 104 in praise of creation. It is in fact ironic that the production of a Huguenot craftsman glorifying his Calvinist god was adapted by his patrons to evoke the bewitched garden of the sensuous and evil enchantress Circe and the empire of Pan, the most earthly Pagan god.[40] Yet it is in a Neoplatonic courtly universe, rather than a Christian evocation of Paradise, that Palissy's grottoes, fountains and garden installation made a final apparition in the most famous court entertainment of the time. His patrons and their audience appreciated his work through their fondness for light, lifelikeness and ingenuity, yet he thought from a very different perspective.

Rather than sight and hearing alone, Palissy privileged the triad of sight, hearing and touch and occasionally used taste as an essential tool in his quest of knowledge. His grotto installations

addressed each of the senses – not only sight and imagination as they did on a theatrical stage. His language, visual or printed, is literal. He does not engage with ancient mythologies and their modern allegorical interpretations – the *lingua franca* of Renaissance court festivals. The only time he alludes to classical mythology is in the context of euhemerism, a doctrine stating that Pagan divinities were merely deified humans.[41] He had also limited knowledge and interest in astrology since he identified the origins of life in the depth of the earth irrigated and flavoured with water and salt rather than in the sky.[42] Unlike his contemporaries, who thought the world and its dwellers composed of four elements, he counted five elements, the fifth and most important of which is a special kind of water. His rustic wares and grotto installations were used by his patron to represent the lowest sublunar layer of the Neoplatonic universe on the scene of their court entertainments, yet his spirituality was Calvinist rather than Neoplatonic. He wanted his work to testify to and show the tangible divinity of nature by taking the print of God's artistry, rather than illustrate the lowest strata of the world. Renaissance Neoplatonism, be it philosophical, mundane or poetic, engages sight and hearing to apprehend incorporeal aspects of the world as a first step towards accessing divinity. Palissy followed a different path towards the same goal, scrutinizing, touching and tasting the earth.

The Sentient World
of Bernard Palissy

By the late 1550s, thanks to Royal patronage and a title especially devised for him –'Inventeur des Rustiques Figulines' – Palissy had reached the highest position a Renaissance artisan could hope for. That he decided to assert his ideas in print and public lectures is unusual. There were many recipe books, of course, but the idea of an artisan publicly defending his profession and putting forward his own philosophy of nature was not common in France (unlike in Italy, for example, where painters did publish in support of their art). In France the main contributors to artistic literature were royal architects such as Sebastiano Serlio (*c.* 1475–1554), a member of Raphael's circle who settled in the country at the invitation of François I, and author of influential architectural treatises. Closer to Palissy the architects of Catherine de' Medici both published: Philibert de l'Orme, a hierarchical superior most disliked by Palissy, and his successor Jacques Androuet du Cerceau (1510–1584). From the time of his employment by Montmorency in the mid-1550s, Palissy somehow felt that he too, like other court artists and intellectuals, could publish his ideas and defend his art. As his experience and knowledge expanded, so grew his conviction that his views were not only right but useful and potentially lucrative, even if they sometimes departed from contemporary common knowledge.

Like most Renaissance artists and artisans, Palissy did not read Latin but benefited from the wave of French translations

that began appearing from the 1540s onwards. Thanks to these he knew Leon Battista Alberti's humanistic treatises on painting, sculpture and architecture, and read the *Hypnerotomachia Poliphili* (1499) of Francesco Colonna (1433/4–1527), a fashionable novel richly illustrated to which he expected his grotto descriptions to be compared.[1] He was acquainted with the works of Paracelsus (d. 1541), Girolamo Cardano (1501–1576), with whom he disagreed, and the naturalist Pierre Belon (1517–1564), whom he wished spent more time studying local fauna. After 1566, once settled in Paris, he frequented jurists, physicians and scientists and undoubtedly learned much from their society and conversation. He even speaks of his 'little academy', suggesting that he organized regular gatherings with learned and like-minded acquaintances to debate questions of philosophy and natural history. One of his interlocutors and friends was François Choisnin, physician to the queen, connected to the circle of Jacques Gohory (1520–1576), involved in alchemy, Paracelsian medicine, Christian Kabbalah and other occult practices.[2] Through Choisnin, Palissy would have also heard of the prophet and orientalist Guillaume Postel, and of the main occultist of the time, Guy le Fèvre de la Boderie (1541–1898), tutor to the queen's youngest son and, like him, a salaried member of the court.[3] These men belonged to the queen's first circle; they shared a Neoplatonic magic view of the world and pinned on the French king their political hopes of a monarch who would dissolve the conflicts brought by the Wars of Religion and bring universal harmony. These networks partly explain Palissy's acquaintance with alchemy, Paracelsian medicine and mineralogy. Yet his work hardly bears any trace of occultism, magic or astrology. He seems to have followed his own path, examining, selecting, assimilating what he heard and read in the light of his own interests and business goals.

Palissy expounded his ideas in two substantial publications, the *Recepte véritable* (1563) and the *Discours admirables* (1580), which

incorporate the material of public lectures and demonstrations delivered in 1575, rewritten as dialogues between two interlocutors: Practice defending his ideas and Theory epitomizing the commonplaces of the time.

Entrepreneurship is central to Palissy, who advertised his knowledge as profitable to his potential patrons and to himself. In this spirit his main writings begin and conclude with essays on the fertilization of the soil. The opening pages of the *Recepte véritable* deal with compost, and the last essay of the *Discours admirables* with marl, lime and manure – all powerful fertilizers. As mentioned in the first chapter, the title *Recepte véritable* puns on the French words for receipt and recipe, and promises wealth to its attentive readers. Such promises are common in recipe books of the time, but there is some truth in the claim made by Palissy, who was considered by scholars as a pioneer in the understanding of fertilizers. The method proposed in the *Recepte* would have improved the harvests and wealth of the landowning readers Palissy was hoping to interest in his expertise. Seventeen years later, in the *Discours admirables*, the same spirit of enterprise is still at work. He advertises his knowledge of water, minerals and plants as much as his skill in setting up fountains in most terrains, while in the introduction he invites potential clients to contact him via his printer.

Beyond his unfaltering entrepreneurship, Palissy's writings unveil the world he represented in his ceramic work and confirm how different his thinking was from that of his patrons and contemporaries. To explore Palissy's personal world view, this chapter examines its principal strata: water, earth, salt, sensory perception in humans and non-humans, and concludes with his ideas on humans, on art and on himself.

WATER

While his contemporaries envisioned humans and the universe according to the balance of its four constituent elements – water, air, fire and earth – Palissy distinguished five elements,[4] the fifth and most important being a distinctive and generative water:

> we can therefore assure that there are two waters, one is evaluative and the other essential, congelative and generative, which two waters are intertwined with each other, in such a way that it is impossible to distinguish them until one of the two is frozen.[5]

Trapped between various geological layers, this primordial water generates gems and minerals; it soaks and solidifies the carcasses of fish, reptiles, batrachians, shells, crustaceans or human remains it crosses in its path. This fifth fluid element does not only produce minerals and fossils; it petrifies as much as it vivifies, it 'germinates every tree and plant and sustains and maintains their formation to the end'. Without it, adds Palissy, 'nothing could say I am.'[6]

Constitutive of the 'I' of things, this fifth element is also at the heart of the sensorium and of the identity, if not humanity, of Palissy himself. Since fifth water is always mixed with common water, it is drunk regularly; consequently, it promotes the growth, solidity and flexibility of bones and provides the foundation of bodily awareness, one early modern version of modern proprioception. The crystal-like transparency of generative water also affects sight: 'the crystalline water which causes sight, has some affinity with generative water, of which spectacles, crystal and mirror are made.'[7] Thus while his contemporaries associated sight with fire, Palissy connects optical and bodily awareness to the properties and action of metallic water.

This elemental thinking informed Palissy's approach to his rustic basins and grotto projects, where he represents water through the brilliance of his ceramics evocative of aquatic glow. Unlike his patrons, who found divine light in the reflectivity of gold, silver and gems, Palissy was seeking it in the transparency and generative properties of water. He even used real water as an extra animated glaze over his *figulines*, for in water he saw the source of all that glows.

EARTH

Palissy's main element is not water but earth, earth as he imagined it fertilized by metallic waters. He calls himself an 'earth worker' (*ouvrier de terre*) and his primary speciality, the art of casting, has its origin in footprints.[8] In the preface of his *Discours admirables* he writes that he spent more than thirty years 'toiling the earth and digging into its entrails in order to know the things it produces in its depths'.[9]

Palissy adopted the views of German physician and philosopher Paracelsus that minerals are in perpetual movement.[10] He also took on the Paracelsian idea that stones grow inside the earth as in a womb: just like fruits they develop from seeds, change colour as they ripen and vary from region to region.[11] For Paracelsus, the influence of the seven planets of the early modern cosmos – the moon, Venus, Mars, Mercury, Jupiter, Saturn and the sun – determines the main characteristics of humans, animals, plants and minerals.[12] For Palissy, on the contrary, all is shaped and fecundated by a fifth element, a metallic water, interacting with subterranean salt.[13] For him the earth is just as active as the starry sky and the ocean:

The Stars and Planets are not idle, the sea pours itself on one side and on the other, and works to produce

profitable things, the earth likewise is never idle: what is consumed naturally in it, it renews and reforms all over again, if not in one way, it does it again in another.[14]

Moreover, following the doctrine of the microcosm and the macrocosm according to which the constitution of the earth is comparable to that of the human body, Palissy asserts: 'the shape and bump of mountains is nothing else than the rocks which are there just as the bones of a man take the form of the flesh in which they are clothed.'[15]

SALT AND TASTE

After water and earth, salt is the third pillar of Palissy's elementary and sensory world. He had first-hand knowledge of the subject since he spent some time observing and drawing the salt marshes of his home province in the 1540s, which he discusses in the treatise on salt in the *Discours admirables*. But this mineral is much more than our familiar table salt. Palissy writes that there are infinite varieties of this crystalline compound.[16] For example, the *Recepte véritable* begins with an essay on compost in which he observes that when rain water washes through a heap of organic matter it flushes away its 'salt', which if retained would enhance the fertility of the soil and produce larger crops.[17] 'There is no part of the earth which is not filled with some kind of salt which causes the generation of several things, be it stones, slates, metals,' he claims.[18] Underground salts infuse everything that grows and determine the flavour and scent of spices, fruits and vegetables as well as their ability to preserve and reproduce.[19] Salt possesses generative power because it is 'hot' inside; 'le sel est chaud interieurement'.[20] Palissy acknowledges the belief that salt invigorates men's genitalia and that oysters are aphrodisiacs since they grow and build their shell by processing sea salt.[21]

Salt has neither specific colour nor texture, so the best tool to discern its presence is the human tongue: 'flavour is nothing but the salt which you taste,'[22] for 'God has put the tongue to fathom the things which are useful for the other parts of the body.'[23] Palissy reports using his tongue to feel and identify the salt in lime, in the dust of certain ores, and to show that the substances of which the tongue cannot dissolve and perceive the salt are unfit for consumption, for 'the body can consume nothing but things from which the tongue can derive some flavour.'[24]

Thus Palissy's approach to taste mostly concerns his quest of knowledge, in complete indifference to the pursuit of culinary pleasure. Yet he served a festive culture of excess, splendour and sensory saturations. Court entertainments addressed the mind and the spiritual senses of sight and hearing; they normally took place after banquets, customarily designed to address and stimulate all the senses, sometimes to the point of saturation. The long reign of Catherine de' Medici introduced Italian tastes and table manners to French court culture and taste buds, as she hired Italian cooks and introduced vegetables previously unknown in France: broccoli, tomatoes, green peas, asparagus and artichokes.[25] While Catherine's pivotal role in the formation of French cookery has been recently revised, there is plenty of evidence to confirm that Valois banqueting was a theatre of excesses. According to the diarist and friend of Palissy, Pierre de L'Estoile, the queen mother herself nearly succumbed to her fondness for artichokes and highly calorific rooster crests during one of the many banquets held in celebration of a marriage: 'The Queen Mother ate so much that she nearly died and was twice sick. It was believed that it was because she ate too many artichoke bottoms and rooster crests and kidneys of which she was very fond.'[26] This anecdote through which Pierre de L'Estoile conveyed his dislike of the queen is further confirmed by the observations of the Venetian ambassadors: 'The Queen Mother greatly loves the comforts of

life; she is disordered in her way of life and she eats a lot . . . her overweight [is] enormous.'[27]

TOUCH, SIGHT, HEARING AND KNOWLEDGE

In the *Discours admirables* Palissy explains that he complemented his public lectures with specimens his audience could examine. For this purpose he built a cabinet to display mineral samples and fossils, 'which are put as testimonies and proofs of my writings, arranged by shelves with some cards written under'.[28] And he adds 'that by proving my written reasons, I satisfy sight, hearing and touch'. Palissy's guided tour of his cabinet, inserted in the appendix to the *Discours admirables*, is filled with interjections to his inter-locutors to use their eye to observe attentively.[29] His attention to the sensory triad of sight, hearing and touch is central to his lec-turing as much as to his grotto projects, for which he stressed the importance of smooth, reflective and resonant surfaces generating light, colour, ambient freshness and reverberating the sounds of gurgling water, windpipes and nearby chirping birds and floral scents. For him colour is not only the object of sight, it is evidence of the life and changing appearance of the earth. Such interest is paralleled, in his ceramics, by his endless experimentations with glazing.

His medium is nature, which he understood and handled as a living and sensitive being not only perceived but perceiving. He discerned tactile consciousness and intelligence in minerals, plants and animals. This understanding of the world nurtured Palissy's approach to agriculture and sets his writings within two traditions of which he probably had only moderate awareness: a philosophical current later called panpsychism and an anti-humanist moral trend contrasting animal wisdom to human foolishness.[30]

PANPSYCHISM

Panpsychism asserts that each individual thing possesses in itself a soul-like or mind-like quality.[31] Hylozoism is a parallel doctrine according to which everything, including matter, is endowed with some form of life, sensation, movement and consciousness. This Palissy believed, although he almost certainly never heard or read these words. The term 'panpsychism' appeared in print one year after his death in the *Nova de universis philosophia* (1591) by Francesco Patrizi (1529–1597). The pre-Socratic philosophers taught Hylozoism around 600 BC but the word itself was coined much later by the Cambridge Platonist Ralph Cudworth (1617–1688).

Intelligent animal behaviour has always challenged assumptions of the human monopoly of reason and wisdom. The ability of plants and animals to reproduce and regenerate hinted at the existence of an active matter animated with a plastic intelligence at work in transforming seeds into flowers, trees, animals and humans. Mere observation prompted exploration of the hypothesis of an operative intelligence in minerals, plants and animals.[32] Through his learned acquaintance, Palissy may have heard of this philosophical tradition, which runs from the pre-Socratics to Plato (428–348 BC), Aristotle, Plotinus (204–270 CE), Ficino and Paracelsus. Palissy was, however, more interested in ideas than in their history and, as we shall see, his grotto work and its architectural terms can be understood as illustrations of the belief that universal generation is rooted in active and conscious matter.

One central question of European philosophy is to distinguish humans from other classes of living beings. Well until the seventeenth century the standard approach, based on Aristotle's treatise *On the Soul* (*c.* 360 BC), was to stack three 'souls' corresponding to three modes of existence cumulated in humans: the vegetative soul, which looks after nutrition and governs plants;

the sensitive soul, common to animals, which includes sensory perception and imagination; and the rational soul, specific to humans and powering judgement, will and memory.[33] In the seventeenth century, René Descartes (1596–1650) famously posited that animals are automata and humans the only holders of a free-thinking soul.[34] Still, daily evidence that animals experience sensations and act upon them implied that they too possess and use rational faculties. In these days of humanist anthropocentrism, if not anthropo-narcissism, this conclusion was mostly dismissed as ludicrous, yet other voices were rising, pointing out that non-humans often behave more reasonably than humans.[35]

Palissy's panpsychic views feature towards the beginning of the *Recepte véritable*, prompted by a confrontation of his ideas to the scepticism of an imaginary interlocutor. After a long and comprehensive exposé on the art of preparing compost he concludes, 'This is . . . why it is necessary for ploughmen to have some Philosophy: otherwise they only abort the earth and bruise the trees.' The implication that trees suffer prompts a dismissive response: 'You claim that trees are men and it seems that they inspire you great pity, you say that ploughmen bruise and hurt them, that is a chatter that makes me laugh.'[36]

In response Palissy asserts that plants suffer; extending tactile awareness to the vegetal world he adds: 'I can assure you that vegetative and insensitive natures suffer in producing their fruits.'[37] And not only in producing fruits. He deplores the wounds inflicted by ignorant peasants on the earth and on plants. He compares the marks left on trees by loggers to life-threatening mutilations and turns to surgery to prescribe a suitable method of pruning trees.[38]

There is plenty of mythological and poetic literature on sentient, whispering and speaking trees.[39] Here, however, this motif relates to the concrete care and nurture of the earth for the specific purpose of enhancing fertility and improving crops. One context (among others) of the *Recepte véritable* is the renewed

interest of French aristocratic landowners in agriculture. This phenomenon inspired a new agrarian literature devoted to practical topics, rather than to the imitation of classical poetry. This is the environment in which early modern bestsellers, such as *L'agriculture et la maison rustique* (1567) by Charles Estienne (1504–1564), emerged, answering the demand for the practical expertise Palissy was proffering.[40]

Consciousness of non-humans returns in the *Recepte véritable* as the prelude to a praise of agriculture as a philosophical discipline. In this section Palissy reports a dream he experienced after meditating on Psalm 104 in praise of God and nature. Entering a heavenly garden, he marvels at 'the wonderful actions that the Sovereign commanded nature to perform'[41] and at the awareness of plants:

> I was contemplating the branches of the vines, peas and courgettes, which seemed to have some feeling and knowledge [*quelque sentiment et cognoissance*] of their weak nature as they were throwing their little arms like nets in the air to find some small branches to attach themselves to.[42]

Sometimes these little arms could not reach any solid branches, so in the morning Palissy gave them pieces of wood to assist them. Still dreaming, he came back in the evening to see that the vines had reached and grabbed the supporting sticks. This anecdote introduces further examples of vegetal and animal consciousness. The keyword is *cognoissance*, an awareness associated with human rationality rather than vegetal faculties. A tree like the walnut, although devoid of sight and hearing, 'has received from God the *cognoissance* of his weak nature' so that he acts accordingly.[43] Orchard trees have also some *cognoissance* since they shelter their fruits with leaves in a fashion comparable to a mother protecting her child. Wheat, hop and chestnut trees have received from God

the *sapience*, that is, the knowledge and wisdom to clothe and protect their fruits with marvellous artistry.[44] Animals too exercise intelligence. Palissy lists examples of their wisdom: the cunning-ness of foxes pretending to be dead to catch unsuspecting preys, the cleverness of hedgehogs carrying apples on their spikes, the expressivity of squirrels, the alertness of hares.

The theme of animal knowledge reappears in the *Discours admirables* in the context of reflections on the origins of fossils. Palissy disputes the patristic belief, which he incorrectly attrib-utes to the philosopher Girolamo Cardano, that fossils found in mountainous areas date from the time of the biblical deluge.[45] After the flood, the sea withdrew promptly from the highest peaks, leaving its fauna stranded in mud where it eventually petrified. Palissy believed that things happened differently. His assertion that fossils were local animals is broadly correct and has been saluted by generations of geologists and palaeontologists. Nevertheless, the first argument he brings forward is ingenious and unusual, insofar as it expresses his belief in animal intelli-gence: 'For it is certain that all species of souls have some knowl-edge of the wrath of God and of the movements of the stars, thunderbolts and storms, and this is seen every day in maritime areas.'[46]

After listing several examples of animals' foreknowledge of natural disasters, he concludes that most creatures would have anticipated the biblical deluge and taken refuge accordingly. There-fore, the biblical account cannot explain the presence of marine fossils in mountainous regions. Anecdotes about animal percep-tions of forthcoming disaster have circulated throughout history up to the present. The subject made headlines at the time of the 2004 tsunami disaster. Unlike humans, who were caught by sur-prise, most animals anticipated the disaster and flew to safety in time, prompting scientific interest in monitoring their perceptivity in the hope of saving lives.

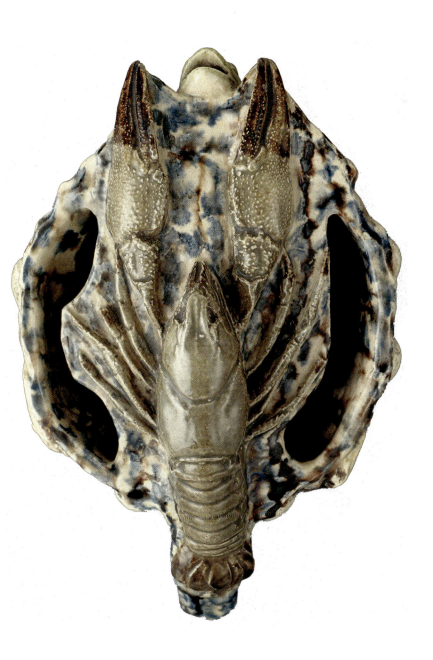

51 Bernard Palissy, ewer with frog and crayfish (detail from illus. 31).

Palissy's attentiveness to the activities of non-humans trans-
lates only distantly into his remaining ceramic work, such as the
Lyon and Louvre rustic basins (illus. 37–9). Their contents
broadly correspond to his description of tepid water but do not
convey the intelligence, alertness and interactions of animals
preying upon each other evoked in his writings. In the basins the
animals just mind their own business. In the Louvre pitcher the
frog and the crayfish seem equally indifferent to their encounter,
although some frogs do feed on crayfish (illus. 51).

ART AND NATURE

While commenting on his own display of minerals and fossils,
Palissy compared the spikes of ores with the thorns of roses and
the scales of sea creatures and marvelled at the ability of all beings
to protect and defend themselves:

> metallic and lapidary materials have shaped for them-
> selves something like a harness, or breastplate on their
> surface, in the manner of pointed stones: as it is given to
> several fish to form for themselves several scales, as you
> see with crayfish and several other kinds of fish.[47]

This skill to produce complex arrangements of scales and spikes
is, for Palissy, evidence of divine artistry. In the multisecular
debate between art and nature, he sided with nature. His rev-
erence for nature as God's work bears the art-theoretical con-
sequence that the products of nature are necessarily superior to
those of human art. This conviction is at the root of Palissy's ideas
on art as well as of his criticism of alchemy, which he viewed as
a rivalry with the work of God, and a particularly foolish one since
alchemists were trying to reproduce with fire a process that Palissy
believed happened naturally by means of metallic water.[48]

The *Discours admirables* offers multiple examples of nature's artistic superiority. Shells not only build their own 'house' but, alluding to their mother-of-pearl interior, Palissy observes that they also decorate their walls with images of rainbows – they literally print rainbows on their walls, something even alchemists cannot achieve, however hard they try to surpass nature.[49] Earlier, in the *Recepte véritable*, Palissy is in search of architectural inspiration. Instead of consulting the treatises of Vitruvius, Serlio or Du Cerceau, he devotes several months to scrutinizing the nests and shelters constructed by mammals, fish and shells.[50] Shells are particularly vulnerable, but God, he adds, has cared so much for them

> that he gave them the industry to know how to make for each of them a house, built and levelled by such Geometry and Architecture that never Solomon in all his Sapience could have known how to do similar things; and even if all the minds of all humans were condensed in a single one, they could not have made the slightest part of this [animal architecture].[51]

Not only oysters can produce their own shells but all beings, including men, have received from God the capacity to protect themselves. Palissy invoked this argument to back up his fortification projects, for although he had no previous experience of military architecture, he considered the military art of self-protection 'more learned by nature, or natural sense, than by practice'.[52] Thus he compared his inclination towards architecture to the natural God-given ability of animals to build and decorate their own shelter.

For Palissy, God grants the faculty of knowing to beings who exercise it independently. He is the supreme artist, his creatures are implicitly external to him: 'Humans must greatly marvel at

the works of God and know that it is great folly to want to imi-
tate him in such a thing.'[53] In a way comparable to the Lutheran
doctrine of justification by faith, which states that humans
cannot match the sacrifice of Christ to obtain salvation, Palissy
believed that not even artists and alchemists can match the work
of God. Such is the religious foundation of his faith in the supe-
riority of nature over art which determined his choice of medium:
casting, taking the print of God's intelligent creations rather
than interpreting and idealizing them by means of drawing or
modelling.

Palissy's religious understanding of nature connects with
Calvin's appreciation of the splendour of colours, of flowers, gold,
silver, ivory and marbles.[54] There is, however, not the slightest
hint of panpsychism in Calvin, whose thought is resolutely anthro-
pocentric. Following the standard Aristotelian division of the
mind into three souls, Calvin believed humans superior to other
animals by virtue of their rational faculties: 'one of the essential
properties of our nature is reason, which distinguishes us from
lower animals.'[55] Thus, yet again, Palissy's independent thinking
sets him apart from some of the most common ideas of his time
on the superiority of humans. He was not alone.

HUMANS AND NON-HUMANS

In the *Recepte véritable*, Palissy's considerations on vegetal and
animal intelligence anticipate a praise of agriculture followed by
a satire on the folly of humans. The integration of these consid-
erations on human foolishness with the earlier praises of vegetal
and animal wisdom sets the *Recepte véritable* in an early modern
moral tradition unfavourably comparing humans to animals; an
impressive genealogy of texts authored by towering figures: Leon
Battista Alberti's *Theogenius* (c. 1440), *L'Asino* (1517) by Niccolo
Machiavelli (1469–1527), *La Circe* (c. 1549) by Giambattista Gelli

(1498–1563), *Histoires prodigieuses* (*c.* 1560) by Pierre Boaistuau (1517–1566) and the *Apologie de Raymond Sebond* (1580) by Michel de Montaigne (1533–1592).[56] There is no evidence that Palissy read any of these authors, although he may have known the French translation of Gelli's *La Circe*, ten dialogues in which the companions of Ulysses, transformed by the enchantress into animals, refuse to reintegrate their human form – except the elephant of the last dialogue, who previously lived as a philosopher.[57]

In the same years, Michel de Montaigne in his *Apologie de Raymond Sebond* presented an extensive demonstration of the superiority of animals over humans. Not only are their senses finer and their bodies stronger, but they are also capable of judgement, memory and will, as well as of virtues such as loyalty, gratitude, magnanimity, clemency, repentance and temperance. To support his views Montaigne quotes anecdotes from a plethora of ancient and modern authors, from whom he concluded 'that it is not by true speech, but by a foolish pride and obstinacy, that we prefer ourselves to other animals, and sequestrate ourselves from their condition and society'.[58]

Whether or not he knew of Montaigne, Machiavelli or Gelli, Palissy partly shared their views on animal temperance and wisdom. In the early 1560s he left the culture of violence of his home town of Saintes only to live and die through the brutality of the French Wars of Religion – a context which offered plenty of evidence that animals behave better than many humans.[59]

Comparing Montaigne's dazzling rhetoric and masterful command of antique and modern sources to Palissy's far more humble approach gives some credence to his claim that he was a man without letters, and that he came to these questions through his lifelong scrutiny of the earth and its dwellers rather than through studying and compiling the opinions of ancient and modern writers. Although he came from a different social and cultural milieu, his ideas converge with those of Gelli and Montaigne. Both invoked

animal intelligence to emphasize human vanity and cast doubts on the alleged superiority of humans, thus undermining the Renaissance humanistic ideal of man as God's gift.[60] But while these authors were only writing on animal behaviour, Palissy went further. He discerned evidence of sensation and thoughtfulness in minerals and vegetables and understood non-human wisdom as a manifestation of the same divine intelligence animating the world. While fifteenth-century thinkers such as Pico della Mirandola or Leonardo perceived themselves as the thinking part of nature, Palissy expressed in his own terms a dissident current identifying nature as the thinking part of humans and non-humans.

THE *OUVRIER* PHILOSOPHER

Palissy's accession to Royal patronage made him an important artisan, yet he remained a hierarchical inferior to the main court artists. These include a string of distinguished masters who served the French monarchy: the Italians Leonardo da Vinci, Benvenuto Cellini (1500–1571), Francesco Primaticcio and Sebastiano Serlio, and French natives including Philibert de L'Orme and Jacques Androuet du Cerceau. They had access to the king and the nobility, commanded considerable salaries and enjoyed luxurious and sophisticated lifestyles. At the time of Palissy, under Catherine de' Medici's patronage these artists and architects were literally setting the foundations of a French national style. In retrospect Palissy was participating in the same enterprise and somehow felt their equal. His profession, however, was still considered a craft. Unlike the visual arts, the arts of the earth had not benefited from 150 years of theoretical literature. Furthermore, although Palissy harboured a royal title apparently specifically created for him, he was only one of several craftsmen working under the supervision of the main court artists. His participation to the *Balet*

comique de la royne, for example, can only be deduced from the description of the grotto, and from evidence that he was in Paris at the time, overseeing the publication of his *Discours admirables* and presenting himself as employed by Catherine de' Medici, who had commissioned the event. In the introduction of the libretto, Beaujoyeulx acknowledges Nicolas Filleul de la Chesnaye's contribution to the text, Girard de Beaulieu's musical composition and the scene designs and engravings of painter Jacques Patin.[61] The name of Palissy, or of whoever provided the material of the grotto of the *Balet comique*, in the unlikely event that it was not him, was clearly not considered important enough to be mentioned by name.[62]

The social ascension of Renaissance painters, sculptors and architects brought changes in the definition of their profession. Since Leon Battista Alberti's *De Pictura*, artists and theoreticians insisted on the intellectual nature of their work, asserting in one way or another that 'We painters are competent without having to use our hands.'[63] The theoretical introduction of Vasari's *Lives of Artists* formalized these claims through the concept of *disegno*, the founding principle of painting, sculpture and architecture. *Disegno*, in the double meaning of drawing and design, is the mental image generated by the imagination and controlled by reason eventually transferred onto a material support.[64] *Disegno* also consecrated the kinship of the visual arts to the liberal arts, traditionally divided in two parts: the quadrivium, with geometry, arithmetic, music and astronomy; and the trivium, with grammar, rhetoric, logic.[65] Unlike the mechanical arts, which encompassed all manual activities practised against a salary for the benefit of human life, the liberal arts only required cognitive efforts and were in principle practised in pursuit of knowledge rather than monetary profit. To demonstrate the liberal status of their profession, artists and theoreticians highlighted that Roman patricians practised their art and stressed their familiarity with

geometry and music theory, both essential to create works endowed
with harmony and proportion. They also transposed to painting
and sculpture the traditional three-parts divisions of rhetoric into
invention, disposition and elocution, replacing elocution with
colour.[66]

The steady implantation of these ideas shadows the social
ascension of Renaissance artists as well as the transition from
workshops to academies characteristic of early modern art edu-
cation. In fact, the first official art academy, founded in Catherine
de' Medici's native Florence by Giorgio Vasari and his entourage
in 1564, was called the Accademia del Disegno. At a more prac-
tical level, the rise of *disegno* accounts for the multiple assignments
of Renaissance court artists routinely providing drawings for
medals, emblems, ornaments, portraits, prints, frescoes, tapestries,
table wares, scene designs, carnival floats, triumphal arches, ban-
ners and suits of armour, as well as costumes for masks, plays and
tournaments.

Palissy knew how to draw, and calls this activity *pourtraiture*,
only a distant relative of the English word 'portraiture' as it refers
to transcribing the visible in graphic format, be it landscape,
minerals, fossils or individuals. By 1543 he had gained enough
experience and reputation to be appointed by the royal tax collec-
tors to draw, or to 'portray', the salt marshes of the Oléron Island
in the Saintonge province. Nothing remains or has been identified
of his graphic work as a surveyor and geologist, and his publica-
tions are not illustrated. He does not seem to have used preparatory
drawings for his ceramic work, which he composed, adjusted and
tweaked until the last firing.[67] His awareness of Renaissance art
theory prompted him to develop opposite views while adopting
the same strategy of emphasizing the liberal character of his core
disciplines: agriculture and ceramics.

From the first lines of the 'avertissement' to the reader of
the *Discours admirables*, Palissy stands against the core assertion

of *disegno* culture that conceptual work holds precedence over practice and experience:

> Those who teach such a doctrine take an ill-founded argu-
> ment, saying that one must visualize in one's mind the
> thing one wants to produce before putting hand to the
> task. If man could represent his imaginations, I would
> hold their side and opinion: but far from it.[68]

Opposing the precedence of theory over practice, of abstract thought over sensory experience, he adds that 'practice has generated theory'.[69]

Palissy disliked Renaissance art theory at least as much as he disliked his hierarchical superior, Philibert de l'Orme, Catherine de' Medici's principal architect and author of several important treatises. The artist from whom he probably took self-fashioning inspiration is a fictional and anonymous figure whose imaginary works feature in Francesco Colonna's *Hypnerotomachia Poliphili* (or *Songe de Poliphile*). Initially printed in Venice in 1499 by the prestigious Aldines Press, the book became fashionable in France thanks to translations published in 1546, 1554 and 1561 and was well known to Palissy and his patrons (illus. 52). The text, pro-fusely illustrated, narrates the rites and festivities of an initiatory journey set in oneiric landscapes. In addition to its gardens, anti-cipating those of the *Recepte véritable*, the *Hypnerotomachia* abounds in descriptions of bas-reliefs, friezes, fountains, basins and ewers where the representation of minerals, flowers, leaves, fruits and animals expresses the parallel refinements of art and nature. Their maker is an anonymous *ouvrier* – *artifice* in the original Italian text – not an *ouvrier* in the modern proletarian sense, but rather someone producing an oeuvre. The ultimate model of the good *ouvrier* is God, 'great ouvrier of the machine of the world'; his opposite is the 'modern stone waster [*gastepierres*], warehouse

HYPNEROTOMACHIE,
OV

Discours du songe
DE POLIPHILE,

Deduisant comme Amour le combat
à l'occasion de Polia.

Soubz la fiction de quoy l'aucteur monstrant
que toutes choses terrestres ne sont que
vanité, traicte de plusieurs matieres
profitables, & dignes de me-
moire.

Nouuellement traduict de langage Italien
en François.

A PARIS.
Pour Iaques Keruer à la Licor-
ne, Rue S. Iaques.

M. D. LXI.

52 *Discours du Songe de Poliphile* (Paris, 1556), title page.

handler [*maneuvrier*], ignorant of good letters and not following
reason'.[70]

The interweaving of art and nature, as much as the erudition
with which minerals and plants are listed in Palissy's *Architecture
et ordonnance de la grotte*, are very close to the French *Songe de Poliphile.*
Not only does Palissy imitate the style of the text but he calls
himself an *ouvrier de terre* in resonance with the *ouvrier* of the *Songe*
whose work also includes 'lizards and snakes moulded on real
ones'.[71] Ironically Palissy was made to play the role of this anony-
mous artisan in the festive world of the queen mother. He devised
and built the rustic setting, fountains and grottoes described in
the *Ballet des Polonais* and the *Balet comique de la royne* but his name
was never mentioned.

When asked to enumerate the qualities needed to succeed
in his profession, Palissy replied concretely: a strong constitution
and enough disposable income to cover the initial expenses which
can be considerable.[72] In spite of the intense physical demands of
his work, he followed the same path as Renaissance art theorists,
highlighting the kinship of his professions –agriculture and the
arts of the earth – with the liberal arts. Claiming that their work
had its foundations in mathematics and geometry was also a
common argument invoked by practitioners of the so-called
mechanical arts to raise the prestige of their profession and claim
higher social status and salaries.[73] Palissy followed this trend.
By titling his first publication *Architecture et ordonnance de la grotte*,
he brought his ceramic installation in parity with the architec-
tural profession. He also defended the liberal status of agriculture
and of the arts of the earth, first in the *Recepte véritable* and later
towards the end of the *Discours admirables*, as a conclusion to his
autobiography.

In the *Recepte véritable* Palissy laments the poor esteem under
which agriculture has fallen and the clumsiness with which it is
practised. He deplores the short-sightedness of those who cut

trees without planting new ones and launches into a discourse on the utility of wood, followed by a criticism of the poor and inadequate instruments used by labourers. In Palissy's practical mind the instruments of a profession are evidence of its high or low status. Thus, when asked by his interlocutor which tools are needed to build his garden and grottoes, he answers that he uses the same implements as architects, since geometry is essential for his work. These are: 'the Ruler, the set Square, the Lead, the Level, the Grasshopper and the Astrolabe'.[74]

He disliked the idea of the precedence of theory over practice and believed in a knowledge informed by experience, which he called philosophy:

> I tell you that there is no art in the world, to which a greater Philosophy is required than agriculture, and I tell you that if agriculture is conducted without Philosophy, it amounts to raping daily the earth and the things it produces: and it is a marvel to me that the earth and nature do not scream out for revenge against those ignorant and ungrateful murderers.[75]

Palissy's philosophy of agriculture rests on his intuition of the earth as an intelligent and sensitive entity. He considered tactile perceptions common to animals, plants and soils. Of this he provides many examples, from the sudden and lethal slamming of the shell of the oyster bitten by a mouse to the trees draping their juicy fruits in silky leaves, or the sufferings of the earth scorched by jagged ploughs. After enumerating examples of vegetal and animal intelligence and meditating on Psalm 104 he adds: 'All these things have made me so fond of agriculture that it seems to me that there is no treasure in the world so precious.'[76]

In the *Recepte véritable* the true benefit of Palissy's philosophy is the practical application of his understanding of the natural

world. Like the products of agriculture, his art rises from the ground up: for fountains he needed to understand the circulation of underground water; for gardens, the correct methods of fertilizing, growing and pruning trees and plants. In this context, ceramics, which relies on the knowledge of soils, metals and ores and the 'government of fire', is another branch of Palissean agriculture and its liberal status is the topic on which Palissy concludes his autobiography.[77]

Like much of Renaissance art, Palissy's work is about showing nature and hiding art. Replying to his interlocutor asking the secrets of his enamels, he only enumerates the ingredients but declines to reveal their proportion. Why be so fussy with what is after all a mechanical art, objects his interlocutor? And indeed pottery, ceramics and agriculture were still considered mechanical arts, practised against a salary and aimed at bodily usefulness, just like occupations such as weaving, tailoring, cookery, trade, warfare, hunting and navigation. Palissy disagreed with this of course and launched a fervent defence of this art as a liberal art. He devoted two pages to explaining the utility and antiquity of the art of the earth, which provides essential building material for houses and temples as much as for ovens and kilns on which depend tile makers, smiths and goldsmiths.[78] Ironically, demonstrating the utility of his art for everyday life and necessity – rather than for the benefit of the mind – went towards the standard medieval definition of the mechanical arts. Yet Palissy's main point was that practising the arts of the earth required a philosophical understanding of the world. He replaced the duality of theory and practice with his philosophy of nature, which is the foundation of the arts of the earth.

FIVE

Afterlives

 alissy's name fell into oblivion until the nineteenth century. Nevertheless, throughout the seventeenth century, the ideas and the style he developed continued their afterlife both in ceramics and philosophy.

POST-PALISSEAN CERAMICS

The redating of many Palissy wares to the beginning of the seventeenth century has not only been backed by scientific analysis. Archival research on workshops active in late sixteenth- and seventeenth-century France have in parallel established the importance of Paris, Rouen and Toulouse as centres of the production and diffusion of glazed rustic earthenware and identified entire networks of potters, far too extensive to sustain the earlier nineteenth-century narrative of a direct and personal influence of Palissy.[1] Research on the provenance of Palissian vessels kept in French museums has tracked down their presence back to seventeenth-century French and German collections and cabinets of curiosities, and suggested that some circulated as diplomatic gifts.[2]

The 36 surviving post-Palissian plates kept in various museums confirm the vitality of the style Palissy contributed to implant into the Royal household.[3] The rise of demand for rustic earthenware with animal casts, implicit in the multiplication of workshops,

53 Louis Ernest Barrias, *Bernard Palissy*, 1883, bronze.

could perhaps be envisaged in the broader context of the contemporary emergence of still-life and animal painting. The literal naturalism heralded by Palissy would precede and converge with the rise of this popular genre during the first decades of the seventeenth century. Palissy rustic work notably anticipates a genre of still-life paintings called *sottobosco*, depicting vipers, lizards, insects and butterflies in their native setting.[4]

From the perspective of the history of philosophical ideas, Palissy's panpsychic views certainly bore no influence on Descartes and his followers, who considered animals soulless automata and imposed dualism as the foundation of European philosophy. There is not much dualism in Palissy, who thinks of nature and himself as a continuum sustained by a fifth fluid element. Palissy's reflection on earth as animated and intelligent is one episode in the long history of the idea of active matter. This history began with the pre-Socratic philosophers, around 600 BC, and continues throughout the sixteenth and seventeenth centuries with figures such as Paracelsus, William Harvey (1578–1657) and Francis Glisson (1597–1677). The question is still relevant to the present in particular through the philosophy of Bruno Latour (1947–2022), and the issues surrounding active matter are central for those in charge of conserving artworks.[5]

Palissy was rediscovered in the eighteenth century by René Antoine Réaumur (1683–1757), Bernard de Fontenelle (1657–1757) and Georges Buffon (1707–1788), who were mostly interested in his scientific ideas. His name rose to unprecedented national fame thanks to the 1777 and 1844 re-editions of his writings. By then, fondly celebrated by Romantic writers such as Honoré de Balzac (1799–1850), Alphonse de Lamartine (1790–1869) and Jules Michelet (1798–1874), he was hailed as a natural genius, an independent mind and a religious rebel who set the foundation of most modern sciences and stood up as the heroic incarnation of unconditional dedication to one's work, faith and mission.[6]

The nineteenth century is one of revivals, a trend branded as 'historicism'. Rather than creating a new style, Gothic, Renaissance, Louis XIV and Louis XV styles were renewed, generating a material culture more often based on the state of scholarship than on concrete objects. Even fashionable dress would, when worn by a single individual, include motifs, shapes and accessories alluding to different centuries.[7] The sixteenth century, although a chaotic and brutal period of civil and religious wars, had become a national golden age, a French Renaissance of arts and letters and therefore a stylistic model to imitate. Its main protagonists were Germain Pilon (1525–1590) and Jean Goujon (1510–1565) in sculpture, Jacques Androuet du Cerceau and Philibert de l'Orme in architecture and, of course, Bernard Palissy in ceramics.[8] The nineteenth-century Palissystes belong to this modern eclecticism, which lasted up to the 1890s when the Renaissance spirit of the

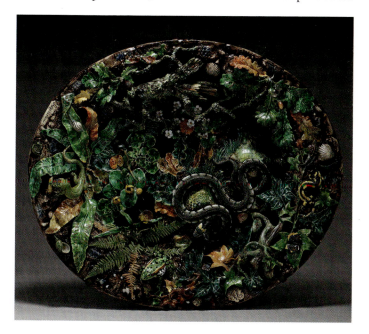

54 Charles-Jean Avisseau, large basin with snake, ferns and bark, *c.* 1850–55, glazed earthenware.

1830s came back in fashion before vanishing in the early twentieth century.[9]

Charles-Jean Avisseau (1795–1861), a native of Tours, initiated the revival of Palissean ceramics and became the leading figure of the French Palissystes (illus. 54). In 1825 Baron de Besenval, a collector and owner of a faience factory in Beaumont-le-Chartif (southwest of Paris), prompted his vocation when he showed him two pieces attributed at the time to Palissy. In a strange parallel narrative with his hero's autobiography, Avisseau devoted more than fifteen years of intense research and experiments to achieve his goal. By 1843 he felt ready to show his work, first in regional and later in international trade exhibitions.[10] Promptly ascending to stellar success, Avisseau was hailed as a new Palissy. He inspired and guided an entire school of followers, who produced pieces in the Renaissance style for a clientele ranging from high bourgeoisie to industrialists and European royalty. The principal Palissystes included Avisseau's brother-in-law, Joseph Landais (1800–1883), Auguste Chauvigné (1829–1904), Léon Brard (1830–1902), Victor Barbizet (1808–1884) and George Pull (1810–1889).[11] Their production commanded high prices and extended to the entire range of known Renaissance ceramics, including maiolica plates and Saint-Porchaire pottery. A painting of the cabinet of Charles Sauvageot (1781–1861), a violinist, civil servant and collector who bequeathed his collection to the Louvre, offers a good glimpse of mid-nineteenth-century French infatuation with the Renaissance (illus. 55).

In Palissy's authenticated ceramics the animals are not really aware of each other; they are arranged for compositional balance and symmetry rather than for narrative. This absence of interaction contrasts with Palissy's lively descriptions of animal behaviour. In this respect the Palissystes are closer to the text of the master than the master himself. Their world is a theatrical stage presenting the daily Darwinian drama of struggle for survival. In Joseph

Landais' adaptations of the Palissean island and snake format, a snake bites the leg of a panicked frog.[12] In Avisseau's *Grand bassin rustique* a snake devours a live salamander and, in his last masterpiece, in a kind of miniature grotto installation incorporating elements of Chinese and Japanese gardens, an owl and a snake engage in a mortal combat over the eviscerated body of an agonizing lizard.[13] Yet in spite of their apparent naturalism, several aspects of the Palissystes' pieces depart from reality. In a fashion reminiscent of Palissy's rustic basins, sea and freshwater animals mingle in the same fictive environment, many have incorrect colours, proportions and anatomy, and some creatures are just invented.[14]

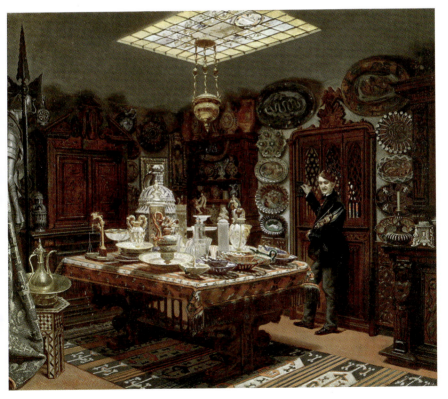

55 Arthur Henry Robert, *Cabinet du Docteur Sauvageot*, 1856, oil on panel.

Some Palissean ceramics were probably used on dinner tables. As mentioned earlier many are listed among other table utensils within Catherine de Medici's inventory.[15] By the nineteenth century, however, they tended to be perceived and treated as artworks rather than as utensils. In Charles Sauvageot's interior, Palissy ceramic plates and rustic basins hang on the wall, just like paintings, framing the figure of the proud collector standing on the right-hand side of the image (illus. 55).[16] The only direct testimony of a practical use comes from Theophile Gautier's account of the cannabis-fuelled meetings of the literary Parisian Club des Hashischins at the Hotel Pimodan:

> The dishes were, for the most part, Bernard Palissy enamels, or earthenware from Limoges, sometimes the carver's knife encountered the real dishes, a reptile, a frog or a bird in relief. The edible eel mingled its folds with the moulded snake.[17]

Palissy's rustic basins had some utilitarian appearance, some space to hold water or even food; those of Avisseau and his followers rarely do. They are demonstrations of virtuosity crafted to be admired and meditated upon like paintings.[18] Like other Romantic artists, the Palissystes considered their art a vehicle of self-expression and signed their work. Avisseau in particular, a devout Catholic, used religious symbols to convey his meditations on life and death.[19]

The Palissystes, whose productions sometimes border on the edge of kitsch, reintroduced natural forms in ceramics thus anticipating the blooming of Art Nouveau. Their most important contribution to the afterlife of Palissy's ideas is their conviction that they were artists rather than artisans. Their success contributed to raise the status of ceramics from craft to 'fine art' and eventually led to the entrance of ceramics, in 1890, to the Parisian

Salon de la Société Nationale des Beaux-Arts, an exhibition space previously reserved for painting and architecture.[20]

These changes, brought about by the French nineteenth-century heroization of Palissy, are part of a broader Western movement which in the twentieth century resulted in the accession of ceramics teaching to higher education.[21] Leading painters have since produced ceramics, including Paul Gauguin (1848–1903), Joan Miró (1893–1983), Pablo Picasso (1881–1973) and Lucio Fontana (1899–1968). These engagements further contributed in blurring the line between art and craft, with the outcome that many modern ceramists consider that they are making art with ceramics in the same ways as others create art through paintings, sculptures, installations or performances. From the late nineteenth century, ceramists contributed to most modern art movements: the Arts and Crafts and Bauhaus, Impressionism, Symbolism, Surrealism, Abstract Expressionism, Minimalism, Pop art, Hyper Realism and beyond.

Thus the reverberations of Palissy's work and ideas extend much further than his nineteenth-century followers. His rejection of Renaissance art theory generated ideas and works converging with several aspects of twentieth-century art, which, like Palissy, had departed from the academism of the time that was distantly rooted in the Renaissance conceptual ideal of the visual arts.

Palissy's approach to producing jasperized marble, which he wanted to apply to his grotto interiors, anticipates the drippings of Jackson Pollock (1912–1956) and Morris Louis (1912–1962) and is merely one episode in the multimillennial traditions of the perception, representation and interpretation of precious marbles, as much as in the growing disinterest in narrative and appreciation of shapes and colours which lead to the abstract paintings of Wassily Kandinsky (1866–1944), Barnett Newman (1906–1970) and Mark Rothko (1903–1970). Similarly, while Palissy production is rooted in the multimedia multisensorial world of

Renaissance court festivals and entertainments, his environmental interventions and work with light and reflection anticipate aspects of modern and contemporary art experiments from Land Art to the works of James Turrell (b. 1943).

FORMS AND ATTITUDES

Twentieth-century interest and concern with gender and gender issues have brought to the forefront some of the forms emerging from Palissy's approach to nature. The vulva shapes implicit in the rustic basins, expressive of Palissy's concept of the earth as the womb of the world, received a controversial afterlife in *The Dinner Party* (1974–9) by Judy Chicago (b. 1939). This work is a large triangular table on each side of which are ceramic plates representing famous women of ancient and modern history. From Sappho to Florence Nightingale, each plate is a ceramic variation on the vulva, serving 'as a reminder that in patriarchal cultures woman has been reduced to her sexual organs', and caused at the time considerable controversy.[22] Its broader context is 'Cunt Art', a California-based movement which produced further variations on female sexual anatomy ranging from miniature to monument with humour and provocation.[23] These are, of course, mere formal analogies rooted in different approaches and ideologies than those guiding the work of Palissy, but they still produce multisensory and multidimensional representations of the same anatomy.

A direct engagement with Palissy's oeuvre features in the works of Belgian sculptor and ceramist Johan Creten (b. 1963), who even exhibited his work alongside the Palissy collections of the Louvre and the Musée de Sèvre. Creten is not a Palissyste but, very much in a Palissean spirit, he is a contemporary artist exploiting the medium of ceramics. He produced a sculpted water wave in homage to Palissy, but perhaps the most Palissean of his works is a series entitled 'Odore di Femmina': here we see an

56 Johan Creten, 'Odore di Femmina' sculpture, 2006, porcelain.

antique fragment of a female torso studded with flowers and bulbs (illus. 56). This piece echoes Palissy's Lyon ewer (illus. 33) as well as the architectural terms of the grotto projects. Shells and roses are filled with feminine sexual associations. Roses, the flowers of Venus, are archetypal signifiers of erotic scent. In Palissy's Lyon ewer, water is a living entity generating elegant, classical curvy contours, as if the object was naturally shaped by a liquid gathering of shells. Similarly, in the architectural terms, human features naturally emerge from mineral and vegetal expansion. 'Odore di Femmina' brings some ambiguity to this imaginary phenomenon of continuity between natural and human forms, for it is both a feminine torso created by the blooming roses and roses blooming from an antique feminine torso.

Trompe l'oeil is another core aspect of Palissy's work. In painting, this genre comprises tricks and formulas ranging from the addition of flies on the surface of late medieval and Renaissance paintings to the introduction of perspective, fictive parapets, painted frames, curtains or pinboards with crumpled pieces of paper. The production of the nineteenth-century Palissystes places perhaps too much emphasis on the display of technique to fully qualify as *trompe l'oeil*. There is, however, a *trompe l'oeil* tradition in twentieth-century ceramics represented by Marilyn Levine (1935–2005), Victor Spinski (1940–2013), Richard Shaw (b. 1941) and Mishima Kimiyo (1932–2024). In the same way that Palissy represents familiar fauna and flora, these modern sculptor-ceramists show everyday objects. The works of Mishima Kimiyo, which delight in painstaking hyper-realist renderings of urban detritus, join Palissy's concerns for the environment in a modern urban key.

Conclusion

Bernard Palissy does not fall neatly into familiar early modern categories. He called himself a 'poor artisan' when he needed to attract patron sympathy, yet instead of following the traditional and long path of craft apprenticeship, from youth to adulthood, he came to his profession as a self-taught mature man and secured royal patronage. Although he directed three workshops – in Saintes, Paris and Sedan – he speaks only in terms of himself, totally concealing the teamwork that sustained his ambition. Even if he distanced himself from the ideas that consecrated the rise of Renaissance artists, preferring agriculture to *disegno*, like them he claimed a philosophical status for his profession. By the time of his arrival in Paris he had become a court artist. This new position granted him access to men of science, many of whom were, like him, salaried members of the French court. Thanks to them he accessed the knowledge he needed to develop and expand his own ideas.

Approaching his work from the angle of his patrons illustrates a very common aspect of the history of art: that those who commissioned art had no interest in the intentions of those who made it. The points of intersection between the Calvinist Palissy and his Catholic patrons are the Renaissance elite taste for nature, light, lifelikeness and ingeniousness. On his side Palissy had endeavoured to show the divine artistry of nature. He worked in the age of mythological dictionaries, emblems and hieroglyphs, all

elements of the pan-European language of court entertainments and festivals. These provided the conceptual building blocks of elaborate court entertainments and Royal entries with floats and triumphal arches laden with symbolic images and speaking sculptures. In this context Palissy's non-narrative, non-symbolic naturalism is an unexpected breath of fresh air. His ceramics shells, turtles, crayfish, lizards and snakes represent only themselves and nothing else, except that they are part of a creative process that begins with water. For these reasons Palissy's works embody a different 'Renaissance' than that visible in the art of Michelangelo and Raphael in theory, in subject, and in practice.

Even if concocted from conversations and readings from Cardano, Belon, Paracelsus, Choisnin and a few others, Palissy's ideas might testify to views more common in visual than in textual culture. His intuition of consciousness across all beings – panpsychism – although a relatively marginal philosophical current in his time, is one of the most illustrated aspects of the Renaissance ornamental tradition which playfully sets a continuity between humans and non-humans through endless, formal variations (illus. 57).

Although the Palissy we know today presents more zones of obscurity than his nineteenth-century avatar, many of his ideas turn out to be compatible with contemporary thought. His writings are screenshots of the intellectual laboratory of an artist operating outside the dichotomies of nature and culture, art and science, theory and practice. To these dualities he opposed a practice informed by sensory scrutiny and geared towards the creation of objects and immersive environments addressing all the senses.

Palissy's environmental thinking is indeed relevant to the present. His tactile empathy with the world at large connects with current ecological deference towards nature. His intuition of intelligence in non-humans anticipates present-day botanists and mycologists who acknowledge that mycelia, plants and trees

57 Jacques Androuet du Cerceau, *Petites grotesques* panel, 1550, etching.

can adapt, protect, defend and feed themselves as well as communicate and interact through networks.[1] His belief in an active, immersive, polymorphous life-giving fifth element now appears as a distant predecessor of modern cosmologies such as those developed by Emanuele Coccia in *The Life of Plants* (2018):

> The world of immersion is an infinite expanse of fluid matter according to varying degrees of quickness and slowness, but especially of resistance or of permeability – because in motion everything aims to penetrate the world and be penetrated by it.[2]

These coincidences have root in Palissy's core discipline – agriculture – for the main thread of his work is the culture of nature, a goal achieved through a respectful understanding of the environment and its dwellers. Thus the return of contemporary philosophy to a non-dualist perspective of the world reopens connections with many aspects of pre-modern thinking in which Palissy shines as a particularly independent-minded actor.

CHRONOLOGY

1510 Bernard Palissy is born in Agen, southwestern France,
1539–40. He settles in Saintes and marries; works as
a glass painter and surveyor

1540 First encounter with Antoine de Pons, governor of
Saintonges; beginning of Palissy's experiments with
enamel

1543 Palissy is appointed by the Royal Tax Collector to inspect
and draw the salt marshes of Oléron Island

1545 Returning from Ferrara, Antoine de Pons favours the
Reformation in his land

1548 Anne de Montmorency, on a visit to Saintonges to repress
a rebellion, acquires some of Palissy's rustic basins

1555 During a stay in Saintes, King Henry II acquires a rustic
basin from Palissy

1556 Anne de Montmorency commissions Palissy to produce
an artificial grotto for one of his castles. Foundation of the
first Reformed church in Saintes. Palissy assists the Calvinist
preacher Philibert Hamelin to establish a Reformed
congregation in Saintes

1559 Treatise of Cateau-Cambresis. Beginning of French Wars
of Religion

1562 Accused of participating in iconoclastic riots, Palissy is
arrested in Saintes and jailed in Bordeaux

1563 While in captivity Palissy writes and publishes the
Architecture et ordonnance de la grotte rustique. He is freed thanks
to Montmorency's intercession. The same year he publishes
the *Recepte véritable*

1565 Catherine de' Medici commissions a grotto for the garden
of the Tuileries Palace

1567	Palissy is settled in Paris and works with his two sons in a studio converted to his specifications in the Tuileries gardens
1572	Some time before the St Bartholomew's Day massacre (23–4 August), Palissy and his family leave Paris for Sedan where he acquires a house and sets up a workshop
1573	The *Ballet des Polonais*, a court entertainment celebrating the accession of Henri de Valois to the throne of Poland, features some of Palissy's works
1575	Palissy delivers public lectures in Paris
1580	Publication of the *Discours admirables*
1581	Performance of the *Balet comique de la royne* featuring some works by Palissy
1585	Treaty of Nemours orders French Protestants to leave, convert to Catholicism or risk capital punishment
1586	Palissy is arrested, freed but required to abjure his religion
1587	He is arrested again and jailed at the Bastille
1590	Palissy dies at the Bastille

REFERENCES

Abbreviations

AO Bernard Palissy, *Architecture et ordonnance de la grotte rustique de Monseigneur le Duc de Montmorency Pair et Connétable de France* (La Rochelle, 1563), available at http://architectura.cesr.univ-tours.fr/traite/Textes/Palissy1563.pdf.

RV Bernard Palissy, *Recepte véritable par laquelle tous les hommes de la France pourront apprendre a multiplier et augmenter leurs thresors . . .* (La Rochelle, 1563), available at https://gallica.bnf.fr.

DA Bernard Palissy, *Discours admirables de la nature des eaux et fonteines, tant naturelles qu'artificielles, des metaux, des sels et salines, des pierres, des terres, du feu et des emaux . . .* (Paris, 1580); all three editions are available at https://gallica.bnf.fr.

OC Bernard Palissy, *Oeuvres complètes*, ed. Marie-Madeleine Fragonard and Keith Cameron, 2nd (revd) edn (Paris, 2010).

Introduction

1 Christian Gendron, 'Les imitateurs de Bernard Palissy au XIXe siècle', *Albineana, Cahiers d'Aubigné*, IV/1 (1992), pp. 201–6.

2 Isabelle Perrin, 'Les techniques céramiques de Bernard Palissy', doctoral thesis, Université Paris-Sorbonne, 1999, pp. 143–9.

3 Pamela H. Smith, *The Body of the Artisan: Art and Experience in the Scientific Revolution* (Chicago, IL, and London, 2004); Pamela H. Smith, *From Lived Experience to the Written Word: Reconstructing Practical Knowledge in the Early Modern World* (Chicago, IL, 2022).

4 See www.sciences-patrimoine.org/projet/figulines, accessed October 2023.

1 Life and Strife

1 Henry Heller, *The Conquest of Poverty: The Calvinist Revolt in Sixteenth Century France* (Leiden, 1986), p. 101.

2 Leonard N. Amico, *Bernard Palissy: In Pursuit of Earthly Paradise* (Paris, 1996), p. 16; DA, p. 172.

3 Amico, *Bernard Palissy*, pp. 233, 236.

4 Ibid., pp. 234–5.

5 DA, p. 271: 'L'on pensoit en nostre pays que je fusse plus sçavant en l'art de peinture que je n'estois, qui causoit que j'estois souvent appellé pour faire des figures pour les procès.'

6 Ibid., p. 187; Monique Pelletier, 'Cartes, portraits et figures en France pendant la Renaissance', in *Cartographie de la France et du monde de la Renaissance au Siècle des lumières* (Paris, 2014), pp. 13–14. I am grateful to Andrea Marie Frisch for this reference.

7 S. Y. Edgerton Jr, *Pictures and Punishment: Art and Criminal Prosecution During the Florentine Renaissance* (Ithaca, NY, and London, 1985), p. 70.

8 Neil Kamil, *Fortress of the Soul: Violence, Metaphysics, and Material Life in the Huguenots' New World, 1517–1751* (Baltimore, MD, 2005), pp. 54–5; Louis Audiat, *Bernard Palissy: étude sur sa vie et ses travaux* (Paris, 1868), pp. 73–5.

9 Jean Parthenay-l'Archevêque, *Mémoires de la vie de Jean Parthenay-L'Archevêque, sieur de Soubise, accompagnés de lettres relatives aux guerres d'Italie sous Henri II et au siege de Lyon (1562–1563)* (Paris, 1879), p. 8.

10 Gabriel Braun, 'Le mariage de Renée de France avec Hercule d'Esté: une inutile mésalliance. 28 juin 1528', *Histoire, économie et société*, VII/2 (1988), p. 155.

11 Ibid., p. 158.

12 Théodore de Bèze, *Histoire ecclésiastique des églises réformées au royaume de France*, vol. I (Lille, 1841) p. 232. On Pons, see Juliette Ferdinand, *Bernard Palissy: artisan des réformes entre art, science et foi* (Berlin and Boston, MA, 2019), p. 25.

13 Alexandre Ceśar Crottet, *Histoire des églises réformées de Pons, Gemozac, et Mortagne, en Saintonge, précédée d'une notice étendue sur l'établissement de la Réforme dans cette province, l'Aunis, et l'Angoumois* (Bordeaux, 1841), p. 87.

14 Polydore Vergile, *Les memoires et histoire de l'origine, invention et autheurs des choses . . .* (Paris, 1576).

15 DA, unpaginated dedication: 'dès le temps que retournastes de Ferrare, en vostre chasteau de Ponts, si est-ce que en ces derniers

iours auquel il vous pleut me parler de sciences diverses, asçavoir de la Philosophie, Astrologie & autres arts tirez des Mathematiques.'

16 Ibid., p. 274.

17 Paul Greenhalgh, *Ceramic, Art and Civilization* (London and New York, 2021), p. 827.

18 Didier Derœux and Daniel Dufournier, 'Réflexions sur la diffusion de la céramique très décorée d'origine française en Europe du Nord-Ouest (XIIIe–XIVe siècles)', *Archéologie médiévale*, XXI (1991), pp. 163–77 (p. 172).

19 Greenhalgh, *Ceramic*, p. 601.

20 Thierry Crépin-Leblond, 'La céramique de Saint-Porchaire', *Technè*, XLVII (2019), pp. 48–50.

21 DA, p. 274: 'l'autheur a appris de soy l'art de terre.'

22 Ibid., p. 291.

23 Marie-Madeleine Fragonard, 'Les meubles de Palissy: biographie d'artiste, légende et mythes', *Albineana, Cahiers d'Aubigné*, IV/I (1992), pp. 25–37.

24 DA, p. 275.

25 Ibid.

26 Ibid., p. 179.

27 Ibid., p. 279.

28 Aurélie Gerbier, 'Du modèle au tirage: le moulage dans l'œuvre de Bernard Palissy', *Technè*, XLVII (2019), pp. 30–32.

29 Bibliothèque nationale de France, ms fr. 64, now edited and available at www.makingandknowing.org, accessed 1 May 2024; see also Amico, *Bernard Palissy*, pp. 86–9.

30 Amico, *Bernard Palissy*, p. 236.

31 Fragonard, 'Les meubles de Palissy', p. 27.

32 DA, p. 286.

33 Fabio Barry, *Painting in Stone: Architecture and the Poetics of Marble from Antiquity to the Age of Enlightenment* (New Haven, CT, and London, 2020).

34 DA, p. 287.

35 Léon Mirot, 'L'hôtel et les collections du Connétable de Montmorency', *Bibliothèque de l'École des chartes*, LXXIX/I (1918), pp. 311–413 (pp. 378–9).

36 Jean Balsamo, 'Le prince et les arts en France au XVIe siècle', *Seizième siècle*, VII/I (2011), pp. 307–32 (p. 309).

37 Brigitte Bedos Rezak, *Anne de Montmorency: seigneur de la Renaissance* (Paris, 1990).

38 Francis Decrue, *Anne, Duc de Montmorency: Connétable et Pair de France, sous les rois Henri II, Francois II et Charles IX* (Paris, 1889), pp. 357–8.

39 Ibid., p. 404.

40 Mirot, 'L' hôtel et les collections', pp. 378–9: 'Un arbre en forme de rocher, semé de coquilles et d'animaus. Deux bassins de forme ovale avec figures de bestes reptiles. Un basin oval, orné d'animaux. Un basin oval, en forme de rocher, semé de coquilles. Avec plusieurs animaux de diverses tailles . . . Un rocher de corail servant de fontaine, où sont plusieurs bestes reptiles . . .'

41 Ibid., p. 396.

42 For the Italian tradition see Vincenzo Cazzato et al., eds, *Atlante delle grotte e dei ninfei in Italia: Toscana, Lazio, Italia Meridionale e Isole* (Milan, 2001).

43 Hervé Brunon, 'Grottes de la Renaissance en France: état de la question', presented at 'Les décors profanes de la Renaissance française. Nouvelles hypothèses', a symposium organized by the Centre d'Histoire de l'Art de la Renaissance, Paris-1 Panthéon-Sorbonne University, directed by Philippe Morel, 19 June 2004, https://halshs.archives-ouvertes.fr, accessed 8 July 2022.

44 Philippe Morel, *Les grottes maniéristes en Italie au XVIe siècle: théâtre et alchimie de la nature* (Paris, 1998), pp. 6–10.

45 Ferdinand, *Bernard Palissy*, pp. 83–6.

46 Amico, *Bernard Palissy*, pp. 30–32.

47 Pamela H. Smith, *From Lived Experience to the Written Word: Reconstructing Practical Knowledge in the Early Modern World* (Chicago, IL, 2022), pp. 139–47.

48 See, for example, the *Bastiment des recettes contenant trois petites parties de receptaires* (Poitiers, 1548), or one of the many editions of Isabella Cortese, *I secreti . . .* (Venice, 1603).

49 Marie-Jeanne Tits-Dieuaide, 'The Evolution of Agricultural Techniques in Flanders and Brabant: 14th–16th Centuries', *Annales*, XXXVI/3 (1981), pp. 362–81; James N. Galloway, 'A Chronology of Human Understanding of the Nitrogen Cycle', *Philosophical Transactions of the Royal Society B: Biological Sciences*, CCCLXVIII/1621 (2013), pp. 1–11 (p. 2).

50 RV, fol. 29r.

51 Luisa Capodieci, *Medicaea Medaea: art, astres et pouvoir à la cour de Catherine de Médicis* (Geneva, 2011), pp. 477–9; Ewa Kociszewska, 'War and Seduction in Cybele's Garden: Contextualizing the "Ballet des Polonais"', *Renaissance Quarterly*, LXV/3 (2012), pp. 809–63 (pp. 839, 841–4).

52 Pascal-François Bertrand, 'A New Method of Interpreting the Valois Tapestries, through a History of Catherine de Médicis', *Studies in the Decorative Arts*, XIV/1 (2006), pp. 27–52; and Ewa Kociszewska, 'Woven Bloodlines: the Valois Tapestries in the Trousseau of Christine de Lorraine, Grand Duchess of Tuscany', *Artibus et historiae*, XXXVII/73 (2016), pp. 1–30.

53 For an overview see Lawrence W. Bryant, *The King and the City in the Parisian Entry Ceremony: Politics, Ritual and Art in the Renaissance* (Geneva, 1986), pp. 21–51.

54 Victor E. Graham and W. McAllister Johnson, *The Royal Tour of France by Charles IX and Catherine de' Medici: Festivals and Entries, 1564–6* (Toronto, 1979).

55 Nicolas Le Roux, 'The Politics of Festivals at the Court of the Last Valois', in *Court Festivals of the European Renaissance*, ed. R. Mulryne and E. Goldring (London, 2002), pp. 101–17.

56 Amico, *Bernard Palissy*, p. 231.

57 Isabelle Perrin, 'Les techniques céramiques de Bernard Palissy', doctoral thesis, Université Paris-Sorbonne, 1999, p. 145.

58 Monique Chatenet, 'Etiquette and Architecture at the Court of the Last Valois', in *Court Festivals of the European Renaissance*, ed. Mulryne and Goldring, pp. 76–100.

59 Kociszewska, 'War and Seduction in Cybele's Garden', p. 839.

60 Amico, *Bernard Palissy*, p. 232.

61 Ibid., p. 233.

62 Ibid., pp. 234–5.

63 Ibid., p. 236.

64 R. J. Knecht, *Catherine De' Medici* (London, 1998), p. 58.

65 Gilbert Schrenck and Eric Surget, 'Bernard Palissy dans l'œuvre d' Agrippa d'Aubigné', *Albineana, Cahiers d'Aubigné*, IV/1 (1992), pp. 17–23 (p. 22).

66 Pierre de L'Estoile, 'Registre Journal de Pierre de L'Estoile', *Mémoires de la Société de l'histoire de Paris et de l'île-de-France*, XXVII (1900), p. 30.

67 Pierre de L'Estoile, *Mémoires-journaux: 1574–1611*, 12 vols (Paris, 1875), vol. V, p. 67: 'il mourut de misère, nécessité et mauvais traictement.'

68 Ibid.: 'Ce bon homme, en mourant, me laissa une pierre qu'il apeloit sa Pierre Philosophale, qu'il assuroit estre une teste de mort que la longueur du temps avoit convertie en pierre, avec une autre, qui lui servoit à travailler en ses ouvrages: lesquels deux pierres sont en mon cabinet, que j'aime et garde soigneusement en mémoire de ce bon

vieillard, que j'ai aimé et soulagé en sa necessité, non comme j'eusse bien voulu, mais comme j'ai peu.

La tante de ce bon homme, qui m'apporta les dites pierres, y estant retournée le lendemain voir comment il se portoit, trouva qu'il estoit mort. Et lui dit Bussi que, si elle le vouloit voir, qu'elle le trouveroit avec ses chiens sur le rampart, où il l'avoit fait trainer, comme un chien qu'il était.'

2 Works

1 Paul Greenhalgh, *Ceramic, Art and Civilization* (London and New York, 2021), p. 827.

2 Ibid., p. 616.

3 Leonard N. Amico, *Bernard Palissy: In Pursuit of Earthly Paradise* (Paris, 1996), pp. 19–20.

4 AO, p. 7.

5 Cennino Cennini, *Il Libro dell'Arte*, ed. F. Tempesti (Milan, 1975), pp. 146–52.

6 See overview in Pamela H. Smith and Tonny Beentjes, 'Nature and Art, Making and Knowing: Reconstructing Sixteenth-Century Life-Casting Techniques', *Renaissance Quarterly*, LXIII/1 (2010), pp. 128–79.

7 Anne Bouquillon, Gaia Ligovich and Gauthier Roisine, 'De la couleur du bestiaire "esmaillé" de Bernard Palissy', *Technè*, XLVII (1997), pp. 51–60; on Palissy glazes, see Isabelle Perrin et al., 'Les glaçures de Bernard Palissy: une technique originale d'opacification', *Technè*, XLVII (2019), pp. 58–64.

8 On Palissy's kilns see Aurélie Gerbier, 'Trois décennies d'études palisséennes: apports d'une approche interdisciplinaire', *Technè*, XLVII (2019), pp. 19–27 (pp. 20–21).

9 AO, p. 7.

10 DA, pp. 282, 284.

11 Amico, *Bernard Palissy*, pp. 60–61.

12 Edmond Bonnaffé, *Inventaire des meubles de Catherine de Médicis en 1589: mobilier, tableaux, objets d'art, manuscrits* (Paris, 1874), pp. 144–5.

13 Ibid., pp. 154–5: 'Six quaisses de boys de sapin plaines de pierres de diverses sortes pour faire rochers et fontaines.' I am grateful to Ewa Kociszewska for this reference.

14 AO, p. 8: 'il n'y a rien de vide.'

15 Ibid., p. 11.

16 Bonnaffé, *Inventaire des meubles de Catherine de Medici*, pp. 144–5.

17 Agnolo Firenzuola, *Dialogo delle bellezze delle donne* (Florence, 1548),
 p. 105; Elizabeth Cropper, 'On Beautiful Women, Parmigianino,
 Petrarchismo, and the Vernacular Style', *Art Bulletin*, LVIII/3 (1976),
 pp. 374–94.

18 Baltasar de Beaujoyeulx, *Le balet comique de la royne* (Paris, 1582),
 fol. 4v–5r.

19 J. L. Benson, 'A Pilgrim Flask of Cosmopolitan Style in the Cesnola
 Collection', *Metropolitan Museum Journal*, XVIII (1983), pp. 5–16 (p. 16).

20 Charlotte Vignon, *The Robert Lehman Collection*, vol. XV: *Decorative Arts*
 (New York, 2012), pp. 172–4.

21 RV, fol. 46v.

22 Pamela H. Smith, *From Lived Experience to the Written Word: Reconstructing
 Practical Knowledge in the Early Modern World* (Chicago, IL, 2022).

23 AO, p. 6: 'Je te peux assurer que l'ouvrier a usé de telle industrie qu'il
 n'y a ride, touche, ni écaille, qu'il ne soit observé en ladite insculpture.'

24 Jean-Claude Plaziat, 'Bernard Palissy (1510–1590) and the French
 Geologists: A Critical Reappraisal Concerning the Founding
 Naturalist and his Rustic Ceramics', *Bulletin de la Société Géologique de
 France*, CLXXXII/3 (2011), pp. 255–67.

25 AO, p. 5.

26 DA, p. 9: 'A la verité telles eaux ne peuvent estre bonnes n'y pour
 les hommes n'y pour les bestes. Car elles sont eschauffees par l'air
 et par le soleil, & par ce moyen engendrent & produisent plusieurs
 espèces d'animaux & d'autant qu'il y a toujours grande quantité de
 grenouilles, les serpents, aspics & vipers se tiennent pres des distes
 claunes: affin de se repaistre desdites grenouilles.'

27 Jean de Léry, *Histoire d'un voyage fait en la terre du Brésil, autrement dite
 Amerique . . .* (Paris 1578), p. 64: 'aussi verte, orde et sale qu'est un vieil
 fossé tout couvert de Grenouilles.'

28 Aristotle, *Poetics*, trans. S. H. Butcher (London, 1922), book IV,
 ch. 2: 'Objects which in themselves we view with pain, we delight
 to contemplate when reproduced with minute fidelity: such as the
 forms of the most ignoble animals and of dead bodies.'

29 Amico, *Bernard Palissy*, p. 231.

30 Ibid., p. 70; Bonnaffé, *Inventaire des meubles de Catherine de Medici*, p. 218.

31 Juliette Ferdinand, *Bernard Palissy: artisan des réformes entre art, science et foi*
 (Berlin and Boston, MA, 2019), p. 11.

32 Beaujoyeulx, *Balet comique*, pp. 4v–5r.

33 AO, p. 62.

34 RV, fol. 29v.

35 Ibid., p. 5: 'Sur le bord dudit fossé y a une terrasse, sur laquelle sont insculpés un nombre infini de poissons, comme sont tortues, écrevisses, chancres, grenouilles, régales et araignées de mer, rougets, brochets, chiens de mer et autres espèces de poissons rares et étranges. Toutes lesquelles espèces de poissons susdites jettent l'eau par la gueule, dedans le fossé, qui est au-dessous de ladite terrasse, en telle sorte, que quand ledit fossé est plein la superfluité de l'eau dégorge par un canal secret et se rend en un grand jardin, qui est au-devant de ladite grotte. Il te faut ici noter que ce grand nombre de pissure d'eaux qui tombent de la gueule des poissons, font mouvoir l'eau qui est dedans le fossé, de sorte qu'on perd le poisson de vue par intervalles, à cause du mouvement de l'eau et de certaines circulations que causent lesdites pissures, de sorte qu'il semble que le poisson se remue dans ledit fossé.'

36 On the rediscovery of the grottesche see N. Dacos, *La découverte de la Domus Aurea et la formation des grotesques à la Renaissance* (London, 1969), pp. 57ff; Philippe Morel, *Les grotesques: les figures de l'imaginaire dans la peinture italienne de la fin de la Renaissance* (Paris, 1997); and C. La Malfa, *Pintoricchio a Roma* (Milan, 2009), pp. 61–73.

37 Hughes Sambin, *Oeuvre de la diversité des termes* (Lyon, 1572), on which see Ferdinand, *Bernard Palissy*, pp. 135–49.

38 RV, fol. 10: 'la geometrie et forme humaine'.

39 Vitruvius, *The Ten Books on Architecture*, trans. Morris Hicky Morgan (Cambridge, MA, 1914), p. 4.

40 Ibid., book IV, p. 7; RV, fol. 33v.

41 RV, fol. 33r: 'tu sais qu'une pourtraiture qui aura esté contrefaite à l'exemple d'une autre pourtraicture qui aura été faites, ne sera jamais tant estimee comme l'original, sur lequel on aura prins le pourtrait. Parquoy les colonnes de pierre ne se peuvent glorifier contre celles de bois . . . d'autant que celles de bois ont engendré ou pour le moins apprins à faire celles de pierre.'

42 Ibid., fol. 32v: 'Et quant est à présent des hommeaux, qui seront la cloture & couverture du dit cabinet ils seront mis & dressez par un tel ordre, que les iambes des hommeaux serviront de colomnes, & les branches seront un architrave, frise & corniche & tympan & frontispiece.'

43 Amico, *Bernard Palissy*, p. 87.

44 Rensselaer Lee, *Names on Trees: Ariosto into Art* (Princeton, NJ, 1977), pp. 3–5.

45 Plotinus, *Enneads*, part II, ch. 3, s. 7.

46 Jacques Gaffarel, *Curiositez inouyes sur la sculpture talismanique des Persans, horoscope des patriarches, et lecture des estoilles* (Paris, 1629), pp. 588–97, for the long genealogy of the idea, and pp. 597–600 on Postel.

47 Ewa Kociszewska, 'Astrology and Empire: A Device for the Valois King of Poland', *Journal of the Warburg and Courtauld Institutes*, LXXIII/1 (2010), pp. 221–55 (pp. 222–3).

48 RV, fols 33v–34r.

49 On Palissy and colour, see Hanna Shell, 'Casting Life, Recasting Experience: Bernard Palissy's Occupation between Maker and Nature', *Configurations*, XII/1 (2004), pp. 1–40; and Bouquillon, Ligovich and Roisine, 'De la couleur du bestiaire esmaillé', RV, fol. 30v.

50 Ibid., fol. 15v.

51 DA, p. 287.

52 RV, fol. 30v: 'Et ainsi les esmails en se liquéfiant, couleront, et en se coulant s'entremesleront, et en s'entremeslant ils feront des figures et ydees for plaisantes.'

53 William Royall Newman, *Promethean Ambitions: Alchemy and the Quest to Perfect Nature* (Chicago, IL, 2004), pp. 157–8.

54 RV, fol. 35v.

55 Ibid., fol. 32v: 'esmaille, enrichie et coloree de diverses couleurs d'esmail qui luiront comme un cristallin.'

3 Reception

1 Leonard N. Amico, *Bernard Palissy: In Pursuit of Earthly Paradise* (Paris, 1996), pp. 231–2.

2 Jean Dorat, *Magnificentissimi spectaculi a regina regum matre in hortis suburbani editi* (Paris, 1573), fol. Fij v; Ewa Kociszewska, 'War and Seduction in Cybele's Garden: Contextualizing the "Ballet des Polonais"', *Renaissance Quarterly*, LXV/3 (2012), pp. 809–63 (p. 841).

3 Amico, *Bernard Palissy*, pp. 40–41.

4 Edmond Bonnaffé, *Inventaire des meubles de Catherine de Médicis en 1589: mobilier, tableaux, objets d'art, manuscrits* (Paris, 1874), pp. 144–5.

5 Amico, *Bernard Palissy*, p. 234; 'Zwei Gesandtschaftsreisen eidgenössischer Boten an den königlich französischen Hof', *Archiv für Schweizerische Geschichte*, XIV (1864), pp. 121–74 (pp. 164–5).

6 Discussed in Monique Chatenet, 'Etiquette and Architecture at the Court of the Last Valois', in *Court Festivals of the European*

Renaissance, ed. J. R. Mulryne and E. Goldring (London, 2002), pp. 76–100.

7 RV, fol. 31r: 'comme si un rocher avoit esté creuse à grans coup de marteaux'; see also AO, pp. 5–6.

8 Pierre de L'Estoile, *Mémoires-journaux: 1574–1611*, 12 vols (Paris, 1875), vol. II, pp. 22–3, 32–4, 58.

9 Ibid., p. 22.

10 Nicolas Le Roux, 'The Politics of Festivals at the Court of the Last Valois', in *Court Festivals of the European Renaissance*, ed. Mulryne and Goldring, p. 252.

11 Luisa Capodieci, *Medicaea Medea: art, astres et pouvoir à la cour de Catherine de Médicis* (Geneva, 2011), p. 587; Roy C. Strong, *Splendour at Court: Renaissance Spectacle and Illusion* (London, 1973), p. 163.

12 Capodieci, *Medicaea Medea*, p. 605.

13 Baltasar de Beaujoyeulx, *Le balet comique de la royne* (Paris, 1582), fol. 6r: 'De laquelle on voyoit pendre de tous costez de beaux & gros raisins, si artificiellement faits que les plus advisez les prenoyent pour naturels & la nature mesme sembloit s'estonner de l'artifice.' See also fol. 6v: 'Dehors le jardin & à ses deux costez y avoit deux treilles voutées, ayant quinze pieds de largeur et vingt quatre de hauteur, avec feuillages et raisins tres beaux & contrefaicts au naturel.'

14 AO, p. 7.

15 Beaujoyeulx, *Balet comique*, fols 4v–5r: 'ie fey dresser une grotte, aussi sombre que le creux de quelque profond rocher; laquelle reluysoit & esclairoit par dehors comme si un nombre infini de diamants y eu esté appliqué.'

16 RV, fol. 36r; see also fol. 35v and AO, p. 5.

17 Beaujoyeulx, *Balet comique*, fol. 5r: 'embellie d'arbres, & revestuë de fleurs, parmi lesquelles on voyoit des lezars & autres bestes si proprement representees qu'on les eust dict estre vives & naturelles.'

18 Ibid., fol. 5r.

19 Ibid., fol. 7r: 'le nombre infiny de flambeaux qui estoyent au dessus de la salle & tout à l'entour, donnoit telle & si grande clairté quelle pouvoit faire honte au plus beau et serein jour de l'annee.'

20 Ibid., fol. 6r: 'contrefait d'or, d'argent, soyes et plumes'.

21 Ibid., fol. 16v: 'qui brilloyent & estinceloyent tout ainsi qu'on voit la nuict les estoiles paroistre au manteau azuré du firmament'.

22 Giorgio Vasari, *Le vite de' più eccellenti pittori scultori e architettori nelle redazioni del 1550 e 1568*, 5 vols, ed. Rosanna Bettarini and Paola Barocchi (Firenze, 1966–87), vol. II, p. 311.

23 François Quiviger, 'Plis, ombres, lumières et mouvements: l'art
 du pli et ses ramifications aux arts du dessin', in *Le Banquet. Manger,
 boire et parler ensemble (XIIe–XVIIe siècles)*, ed. Bruno Laurioux,
 Agostino Paravicini Bagliani and Eva Pibiri (Florence, 2018),
 pp. 287–98.
24 Thierry Crépin-Leblond, ed., *Le dressoir du prince: services d'apparat à la
 Renaissance*, exh. cat., Musée National de la Renaissance, Château
 d'Écouen (Paris, 1995).
25 On the rustic style see Ernst Kris, *Le style rustique: le moulage d'après
 nature chez Wenzel Jamnitzer et Bernard Palissy; suivi de Georg Hoefnagel et le
 naturalisme scientifique* (Paris, 2005).
26 RV, fol. 47r.
27 Ibid., fol. 44v.
28 Amico, *Bernard Palissy*, pp. 43–4.
29 Carl A. Shaw, '"Genitalia of the Sea": Seafood and Sexuality in
 Greek Comedy', *Mnemosyne*, LXVII/4 (2014), pp. 554–76
 (pp. 560–62).
30 Monique Kornell and Dániel Margócsy, '"A Spring of Immortal
 Colours": Jacques Le Moyne de Morgues (*c.* 1533–1588) and
 Picturing Plants in the Sixteenth Century', *Journal of the Warburg and
 Courtauld Institutes*, LXXXVI (2023), pp. 109–57 (p. 152).
31 Pierre de Bourdeille de Brantôme, *Vie des dames illustres françaises et
 etrangères*, vol. II: *Oeuvres* (Paris, 1787), pp. 289–90.
32 Bonnaffé, *Inventaire des meubles de Catherine de Médicis*, pp. 144–5. See
 also Isabelle Perrin, 'Les techniques céramiques de Bernard Palissy',
 doctoral thesis, Université Paris-Sorbonne, 1999, pp. 25–33.
33 See, in particular, Frances A. Yates, *The French Academies of the Sixteenth
 Century* (London, 1947); and Capodieci, *Medicaea Medea*.
34 Giovanni Pico della Mirandola, *Oration on the Dignity of Man*, trans.
 A. Robert Caponigri (Chicago, IL, 1956), p. 8.
35 Marie-Joëlle Louison-Lassablière, 'Brantôme et les danses de cour'
 (2008), https://cour-de-france.fr, accessed 15 September 2023.
36 David C. Lindberg, 'The Genesis of Kepler's Theory of Light: Light
 Metaphysics from Plotinus to Kepler', *Osiris*, II/1 (1986), pp. 4–42
 (p. 23).
37 Ewa Kociszewska, 'The Sun King in the Realm of Eternal Winter',
 French Studies Bulletin, XXX/113 (2009), pp. 78–82 (p. 79).
38 Capodieci, *Medicaea Medaea*, p. 523.
39 Beaujoyeulx, *Balet comique*: 'Au lecteur: . . . je puis dire avoir contenté
 en un corps bien proportionné l'oeil, l'oreille & l'entendement.'

40 Ibid., fols 4v–5r; Capodieci, *Medicaea Medaea*, pp. 600–626.
41 DA, p. 53.
42 Ibid., pp. 146, 199.

4 The Sentient World of Bernard Palissy

1 RV, unpaginated dedication.
2 Ewa Kociszewska, 'Astrology and Empire: A Device for the Valois King of Poland', *Journal of the Warburg and Courtauld Institutes*, LXXIII/1 (2010), pp. 221–55 (pp. 222–3). On Palissy's acquaintances, see Louis Audiat, *Bernard Palissy: étude sur sa vie et ses travaux* (Paris 1868), pp. 205–19.
3 Kociszewska, 'Astrology and Empire', p. 224.
4 DA, p. 73: 'ne sçais tu pas que l'eau est l'un des elements, voire le premier entre tous, sans lequel nulle chose ne pouvait prendre commencement? ie dy nulle chose animée, ny vegetative, ny mineral, ne mesme les pierres . . .'
5 Ibid., p. 126: 'nous pouvons donc assurer qu'il y a deux eaux, l'une est evaluative et l'autre essencive, congelative et generative, lesquelles deux eaux sont entremeslées l'une par l'autre, en telle sorte qu'il est impossible les distinguer au paravant que l'une des deux soit congelée.'
6 Ibid., p. 128: '[une eau] sans laquelle nulle chose ne pouroit dire je suis; c'est elle qui germine tous arbres et plantes et qui soutient et entretient leur formation jusqu'a la fin . . .'
7 Ibid., p. 128: 'l'eau crystalline qui cause la veüe, a quelque affinité avec l'eau générative, de la laquelle les lunettes, le cristal & miroir sont faits.' See also pp. 311–12.
8 Ibid., p. 314: 'la moullerie peut avoir ésté inventé par les pas d'un homme qui marcha les pieds nuds sur le sable'.
9 Ibid., p. 3: 'gratter la terre, l'espace de quarante ans, & foüiller les entrailles d'icelle, à fin de conoistre les choses qu'elle produit dens soy.'
10 Ibid., p. 18: 'les pierres croissent en la terre'. Source in Paracelsus discussed in Jean Céard, 'Relire Bernard Palissy', *Revue de l'Art*, LXXVIII/1 (1987), pp. 77–83 (p. 81).
11 DA, p. 252.
12 Pamela H. Smith, *From Lived Experience to the Written Word: Reconstructing Practical Knowledge in the Early Modern World* (Chicago, IL, 2022), pp. 56–7.
13 DA, p. 18: 'il n'y a aucune partie en la terre qui ne soit remplie de quelque espece de sel qui cause la generation de plusieurs choses'.

See also DA, p. 128. For the references to Paracelsus, see Hiro Hirai, 'Logoi Spermatikoi and the Concept of Seeds in the Mineralogy and Cosmogony of Paracelsus', *Revue d'histoire des sciences*, LXI/2 (2008), pp. 1–21.

14 RV, fol. 18r: 'Les Astres & Planetes ne sont pas oisives, la mer se pourmeine d'un côté et d'autre, & se travaille à produire choses profitables, la terre semblablement n'est jamais oisive: ce qui se consomme naturellement en elle, elle le renouvelle & le reforme derechef, si ce n'est en une sorte, elle le refait en une autre.' On metals as seeds, see also DA, pp. 87–9.

15 RV, fol. 16v: 'la forme et bosse des montagnes n'est autre chose que les rochers qui y sont tout ainsi comme les os d'un homme tiennent la forme de la chair de laquelle ils sont revêtus'. See Martin Kemp, *Leonardo Da Vinci: The Marvelous Works of Nature and Man* (Cambridge, MA, 1981), pp. 71–136.

16 RV, fol. 10v.

17 Ibid., fol. 12rv.

18 DA, p. 18.

19 RV, fol. 16v: 'Il n'y a aucune partie de la terre qui ne soit remplie de quelque espèce de sel qui cause la génération de plusieurs choses, soient pierres, ardoises, metal.'

20 DA, p. 306.

21 Ibid., p. 174; OC, p. 404; also mentioned in Levin Lemnius, *Les occultes merveilles* (Paris, 1567), p. 337.

22 DA, p. 148: 'laditte saveur n'est autre chose que le sel que tu tastes.' See also RV, fol. 26v.

23 DA, p. 147: 'Dieu a mis la langue pour sonder les choses qui sont utiles pour les autres parties du corps.'

24 Ibid., p. 147: 'le corps ne peut rien consommer sinon les choses desquelles la langue puisse tirer quelque saveur.' See also RV, fols 11v, 23v, 26v and 28r: 'Considère un peu toutes les choses qui sont bonnes à manger et à restaurer, et tu trouveras que soudain qu'elles sont sur la langue, elles se commencent à se dissoudre; car autrement, la langue ne pourroit juger de la saveur des choses.'

25 Loïc Bienassis and Antonella Campanini, 'La reine à la fourchette et autres histoires. Ce que la table française emprunta à l'Italie: analyse critique d'un mythe', in *La table de la Renaissance: le mythe italien*, ed. Pascal Brioist and Florent Quellier (Tours, 2022), p. 10.

26 Pierre de L'Estoile, *Mémoires-journaux: 1574–1611*, 12 vols (Paris, 1875), vol. I, pp. 64–5 for June 1575: 'la Roine-Mère mangea tant qu'elle

cuida crever, et fust malade au double de son devoiement. On disoit que c'estoit d'avoir trop mangé de culs d'artichaux et de crestes et rognons de coq, dont elle estoit fort friande.' See Bienassis and Campanini, 'La reine à la fourchette et autres histoires'.

27 Quoted by Bienassi Campanini in 'La reine à la fourchette et autres histoires', p. 10. 'La reine mère aime fort les commodités de la vie ; elle est désordonnée dans sa manière de vivre et elle mange beaucoup [. . .] son embonpoint [est] énorme.'

28 DA, p. 347: 'un cabinet auquel l'on verra des choses merveilleuses qui sont mises pour témoignages et preuves de mes écrits, attachés par étages avec certains écriteaux au dessous . . . en prouvant mes raisons escrittes, ie contente la veüe, l'ouïe et l'attouchement.' See also pp. 230, 347–61.

29 Ibid., p. 347–61.

30 RV, fol. 43r.

31 David Skrbina, *Panpsychism in the West* (London, 2005), p. 39.

32 See Guido Giglioni, 'Active Matter: A Philosophical Aberration or a Very Old Belief?', in *Conserving Active Matter*, ed. P. Miller (New York, 2022), pp. 164–85; and 'Plantanimal Imagination: Life and Perception in Early Modern Discussions of Vegetative Power', in *Vegetative Powers: The Roots of Life in Ancient, Medieval and Early Modern Natural Philosophy*, ed. Fabrizio Baldassarri and Andreas Blank (New York, 2021), pp. 325–45.

33 Aristotle, *De Anima*, book II, part 3.

34 Summary in Erica Fudge, *Brutal Reasoning: Animals, Rationality, and Humanity in Early Modern England* (Ithaca, NY, and London, 2006), ch. 1.

35 For the philosophical debate, see Cecilia Muratori, 'Between Machinery and Rationality: Two Opposing Views on Animals in the Renaissance and their Common Origin', *Lo Sguardo Rivista di Filosofia*, XVIII/2 (2015), pp. 11–22.

36 RV, fol. 13r: 'Voila . . . pourquoy il est requis que les laboureurs ayent quelque Philosophie: ou autrement, ils ne font qu'avorter la terre et meurtrir les arbres.
-Tu fais ici semblant que des arbres ce sont des hommes, et semble qu'ils te font grand pitié, tu dis que les laboureurs les meurtrissent, voila un propos qui me fait bien rire.'

37 DA, p. 19: 'ie te puis assurer que les natures végétatives et insensibles souffrent en produisant leurs fruits.'

38 Ibid., p. 18r.

39 Michael Marder, 'To Hear Plants Speak', in *The Language of Plants: Science, Philosophy, Literature*, ed. Monica Gagliano, John C. Ryan and Patrícia Vieira (Mineapolis, MN, 2017), p. 112.

40 Florent Quellier, 'L'automne horticole du Moyen Age, permanences médiévales dans les traités de jardinage de la première modernité (1486–1652)', *Archéologie du Midi Médiéval*, XXIII/1 (2005), pp. 109–17 (pp. 110–11).

41 RV, fol. 42r: 'les merveilleuses actions que le souverain a commandé de faire à la nature'.

42 Ibid., fol. 42r: 'ie contemplois les rameaux des vignes, des pois et des coyes, lesquelles sembloyent qu'elles eussent quelque sentiment et connaissance de leur débile nature, elle iettoyent certains petits bras, comme filets en l'air, et trouvans quelques petite branche ou rameau, se venoyent lier et attacher sans plus partir de là.'

43 Ibid., fol. 42r: 'Dieu lui a donné cognoissance de la debilite de sa nature.'

44 Ibid., fol. 48r: 'l'apperceu aussi le froment et autres bleds ausquels le Souverain avoit donne sapience de vetir leur fruits.'

45 Girolamo Cardano, *Les livres de Hiérome Cardanus, . . . intitulés de la subtilité . . .* (Paris, 1556), p. 151v. On the history of the interpretation of fossils, see Martin J. S. Rudwick, *The Meaning of Fossils: Episodes in the History of Palaeontology* (Chicago, IL, 1985), pp. 37–8.

46 DA, p. 212: 'Car il est certains que toutes especes d'ames ont quelque connoissance du courroux de Dieu & des mouvements des astres, foudres et tempetes, & cela se voit tous les jours és parties maritimes.'

47 DA, p. 355: 'aussi les matieres metalliques et lapidaires se forment comme un harnois, ou corps de cuirasse sur la superficie, en façon de pierre poinctues: comme il est donné à plusieurs poissons de se former plusieurs escailles, ainsi que tu vois aux ecrevisses et plusieurs autres genres de poissons'.

48 See William Royall Newman, *Promethean Ambitions: Alchemy and the Quest to Perfect Nature* (Chicago, IL, 2004), pp. 145–62.

49 DA, pp. 107–8.

50 RV, fols 57v–59r.

51 Ibid., fol. 58v: 'Qu'il leur a donné industrie de savoir faire à chacun d'eux une maison, et contruite et nivelée par une telle Geometrie et Architecture que jamais Salomon en toute sa Sapience ne seut faire choses semblable; et quand même tous les esprits des humains seroyent assemblez en un, ils n'en sauroient avoir fait le plus moindre trait.'

52 Ibid., fol. 3r: 'plus apprins par nature, ou sens naturel, que non pas par la pratique'.

53 DA, p. 110: 'les hommes devroyent grandement s'esmerveiller des oeuvres de Dieu et connoistre que c'est une grande follie de le penser imiter en telle chose . . .'

54 Jean Calvin, *Institution de la religion chrétienne* (Genève, 1888), X, 2, p. 599.

55 Ibid., II, 17, p. 238.

56 See Nicola Bonazzi, '"Animale irrequieto e impazientissimo": naturalismo e moralità in Alberti, Machiavelli e Bruno', in *Dalla parte dei sileni. Percorsi nella letteratura italiana del cinque al seicento* (Bologna, 2016), pp. 9–29.

57 Fanny Eouzan, 'La Circé de Giovan Battista Gelli', *Italies: Littérature – Civilisation – Société*, XXI (2017), pp. 491–5.

58 Michel de Montaigne, *Essais*, XII, ii: 'Par où il appert que ce n'est par vray discours, mais par une fierté folle et opiniastreté, que nous nous preferons aux autres animaux, et nous sequestrons de leur condition et societé'.

59 Marc Seguin, 'Mentalités et délinquances saintongeaises au temps de Bernard Palissy', *Albineana, Cahiers d'Aubigné*, IV/I (1992), pp. 39–56.

60 Hassan Melehy, 'Montaigne and Ethics: The Case of Animals', *L'esprit Créateur*, XLVI/I (2006), pp. 96–107 (p. 99).

61 Baltasar de Beaujoyeulx, *Balet comique de la royne* (Paris, 1581), p. 3.

62 On the lower status of ceramists see Juliette Ferdinand, *Bernard Palissy: artisan des réformes entre art, science et foi* (Berlin and Boston, MA, 2019), pp. 47–9.

63 Paolo Pino, 'Dialogo di Pittura' [1548], in *Trattati d'arte del Cinquecento*, vol. I, ed. P. Barocchi (Bari, 1960), p. 107.

64 Giorgio Vasari, *Le vite de' più eccellenti pittori scultori et architetti nelle redazioni del 1550 e 1568*, 5 vols, ed. Rosanna Bettarini and Paola Barocchi (Firenze, 1966–87), vol. I, pp. 42–6.

65 Paul Oskar Kristeller, 'The Modern System of the Arts: A Study in the History of Aesthetics', *Journal of the History of Ideas*, XII/4, pp. 496–527; XIII/I (1952), pp. 17–46.

66 See Pino, 'Dialogo di pittura'; Lodovico Dolce, *L'Aretino* (Venice, 1559).

67 Aurélie Gerbier, 'Du modèle au tirage: le moulage dans l'œuvre de Bernard Palissy', *Technè*, XLVII (2019), pp. 30–32.

68 'Ceux qui enseignent telle doctrine prennent argument mal fondé, disant qu'il faut imaginer et figurer la chose que l'on veut faire en

son esprit & figurer la chose que l'on veut faire devant que mettre la main a sa besogne. Si l'homme pouvait exécuter ses imaginations, ie tiendrais leur party et opinion: mais tant s'en faut . . .'

69 Smith, *From Lived Experience to the Written Word*, p. 124.

70 Francesco Colonna, *Hypnérotomachie ou Discours du Songe de Poliphile . . . nouvellement traduict de langage Italien en François*, ed. Jean Martin (Paris, 1561), fol. 46v.

71 Ibid., fol. 70v: 'des lezards & couleuvres moulées sur le naturel'. See also fols 32v, 61r.

72 DA, pp. 270–71.

73 Smith, *From Lived Experience to the Written Word*, p. 138.

74 RV, fol. 45r: 'La Reigle, l'Escarre, le Plomb, le Niveau, la Sauterelle & l'Astrolabe'. The Grasshopper is a type of set square used by surveyors; see OC, p. 197, n. 446.

75 RV, fol. 8r: 'Je te dis qu'il n'est nul art au monde, auquel soit requis une plus grande Philosophie qu'à l'agriculture, & te dis que si l'agriculture est conduite sans Philosophie, que c'est autant que journellement violer la terre, & les choses qu'elle produit: & m'emerveille que la terre & natures produites en icelle ne crient vengeance contre certains meurtrisseurs, ignorants et ingrats.'

76 Ibid., fol. 45r: 'Toutes ces choses m'ont rendu si amateur de l'agriculture qu'il me semble qu'il n'y a thresor au monde si precieux.'

77 DA, pp. 292–5.

78 Ibid., pp. 293–5.

5 Afterlives

1 Jessica Denis-Dupuis, 'Sur les traces des producteurs de céramiques à glaçure plombifère et à décor moulé des règnes de Henri IV et de Louis XIII', *Technè*, XLVII (2019), pp. 62–71.

2 Françoise Barbe, François Coulon and Jessica Denis-Dupuis, 'Le collectionnisme des XVIIe et XVIIIe siècles. Les céramiques post-palisséennes de provenance ancienne dans les collections françaises', *Technè*, XLVII (2019), pp. 80–89.

3 Isabelle Perrin, 'Les techniques céramiques de Bernard Palissy', doctoral thesis, Université Paris-Sorbonne, 1999, pp. 291–347.

4 Karin Leonhard, 'Pictura's Fertile Field: Otto Marseus van Schrieck and the Genre of Sottobosco Painting', *Simiolus: Netherlands Quarterly for the History of Art*, XXXIV/2 (2009–10), pp. 95–118.

5 P. Miller, ed., *Conserving Active Matter* (New York, 2022).

6 Anne-Marie Lecoq, 'Morts et résurrections de Bernard Palissy', *Revue de l'Art*, LXXVIII (1987), pp. 26–32 (pp. 26–7); Matthias Waschek, 'Avisseau, le mythe de Palissy et la naissance de la céramique artistique moderne', in Danielle Oger, *Un bestiaire fantastique: Avisseau et la faïence de Tours, 1840–1910* (Paris, 2002), pp. 19–25.

7 Alexandra Bosc, 'Chérusques, manches, gigot et cols Médicis: les modes néo-renaissance dans la garde robe féminine du XIXe siècle', in *Revivals: l'historicisme dans les arts décoratifs français au XIXe siècle*, ed. Anne Dion-Tenenbaum and Audrey Gay-Mazuel (Paris, 2020), p. 209.

8 Anne Dion-Tenenbaum, 'Redécouvrir la Renaissance: collections, études et créations', in *Revivals*, ed. Dion-Tenebaum and Gay-Mazuel, p. 44.

9 Anne Dion-Tenenbaum and Audrey Gay-Mazuel, 'Un siècle en quête de style', in *Revivals*, ed. Dion-Tenebaum and Gay-Mazuel, pp. 12–13.

10 Danielle Oger, 'La faïence de Tours (1840–1910): Avisseau et le souffle de la Renaissance', *Sèvres: Revue de la Société des Amis du musée national de Céramique*, XII/1 (2003), p. 53.

11 Christian Gendron, 'Les imitateurs de Bernard Palissy au XIXe siècle', *Albineana, Cahiers d'Aubigné*, IV/1 (1992), pp. 201–6.

12 Victoria and Albert Museum, London, inv. 2815–1856, reproduction in Oger, *Un bestiaire fantastique*, pp. 116–17; Pierre Cabard, 'Faune et Flore', ibid., pp. 47–8.

13 Oger, *Un bestiaire fantastique*, pp. 120, 126–7.

14 Pierre Cabard, 'Faune et Flore', pp. 44–7.

15 Edmond Bonnaffé, *Inventaire des meubles de Catherine de Médicis en 1589: mobilier, tableaux, objets d'art, manuscrits* (Paris, 1874), pp. 144–5.

16 Waschek, 'Avisseau, le mythe de Palissy', p. 23.

17 Théophile Gautier, *Le club des hachichins* (Kindle edition, 2020): 'Les plats étaient, pour la plupart, des émaux de Bernard Palissy, ou des faïences de Limoges, quelquefois le couteau du découpeur rencontrait, les mets réels, un reptile, une grenouille ou un oiseau en relief. L'anguille mangeable mêlait ses replis à de la couleuvre moulée.'

18 Marie-Aimée Suire, 'De Saint-Porchaire à Parthenay sur les traces de la faïence fine poitevine. Des origines énigmatiques', *Sèvres: Revue de la Société des Amis du musée national de la Céramique*, XXIII/1 (2014), pp. 93–102 (p. 94); Waschek, 'Avisseau, le mythe de Palissy', p. 23.

19 Oger, 'La faïence de Tours (1840–1910)', pp. 47–8.

20 Waschek, 'Avisseau, le mythe de Palissy', p. 24.

21 Paul Greenhalgh, *Ceramic, Art and Civilization* (London and New York, 2021), ch. 8, part 3.
22 Carol Snyder, 'Reading the Language of the Dinner Party', *Women's Art Journal*, 1/2 (1980), pp. 30–34 (p. 32).
23 Emma L. E. Rees, *The Vagina: A Literary and Cultural History*, 2nd (revd) edn (New York, 2014), ch. 4: 'Revealing the Vagina in the Visual Arts'.

Conclusion

1 Monica Gagliano, John C. Ryan and Patrícia Vieira, *The Language of Plants: Science, Philosophy, Literature* (Minneapolis, MN, 2017). On Palissy's ecological concerns see Jeremy Robin Schneider, 'Hunted to Extinction: Finding Lost Species in the World of Bernard Palissy (1510–89)', *Renaissance Quarterly*, LXXVII/2 (2024), pp. 493–528.
2 Emanuele Coccia, *The Life of Plants: A Metaphysics of Mixture* (Medford, MA, 2018).

SELECT BIBLIOGRAPHY

Sources

Beaujoyeulx, Baltasar de, *Le balet comique de la royne* (Paris, 1582)

Bèze, Théodore de, *Histoire ecclésiastique des églises réformées au royaume de France*, vol. 1 (Lille, 1841)

Bonnaffé, Edmond, *Inventaire des meubles de Catherine de Médicis en 1589: mobilier, tableaux, objets d'art, manuscrits* (Paris, 1874)

Calvin, Jean, *Institution de la religion chrétienne* (Genève, 1888)

Cardano, Girolamo, *Les livres de Hiérome Cardanus, . . . intitulés de la subtilité et subtiles inventions, ensemble les causes occultes et raisons d'icelles, traduis de Latin en François par Richard Le Blanc* (Paris, 1556)

Colonna, Francesco, *Hypnérotomachie ou Discours du Songe de Poliphile . . . nouvellement traduict de langage Italien en François,* ed. Jean Martin (Paris, 1561)

Dorat, Jean, *Magnificentissimi spectaculi a regina regum matre in hortis suburbani editi* (Paris, 1573)

Estienne, Charles, and Jean Liebault, *L'agriculture et maison rustique* (Lyon, 1578)

Firenzuola, Agnolo, *Dialogo delle bellezze delle donne* (Florence, 1548)

Graham, Victor E., and W. McAllister Johnson, *The Royal Tour of France by Charles IX and Catherine de' Medici: Festivals and Entries, 1564–6* (Toronto, 1979)

Jouan, Abel, *Recueil et discours du voyage du Roy Charles IX faict et recueilly par Abel Jouan* (Paris, 1566)

Palissy, Bernard, *Discours admirables de la nature des eaux et fontaines, tant naturelles qu'artificielles, des métaux, des sels et salines, des pierres, des terres, du feu et des émaux . . .* (Paris, 1580)

—, *Oeuvres complètes*, ed. Marie-Madeleine Fragonard and Keith Cameron, 2nd (revd) edn (Paris 2010)

—, *Recepte véritable par laquelle tous les hommes de la france pourront apprendre à multiplier et augmenter leurs thrésors . . .* (La Rochelle, 1563)

Parthenay-l'Archevêque, Jean, *Mémoires de la vie de Jean Parthenay-L'Archevêque sieur de Soubise, accompagnés le lettres relatives aux guerres d'Italie sous Henri II et au siège de Lyon (1562–1563)* (Paris, 1879)

Pico della Mirandola, Giovanni, *Oration on the Dignity of Man*, trans. A. Robert Caponigri (Chicago, IL, 1956)

Sambin, Hugues, *Oeuvre de la diversité des termes, dont on use en architecture* … (Lyon, 1572)

Vasari, Giorgio, *Le vite de' più eccellenti pittori scultori e architettori nelle redazioni del 1550 e 1568*, 5 vols, ed. Rosanna Bettarini and Paola Barocchi (Firenze, 1966–87)

Studies

Amico, Leonard N., *Bernard Palissy: In Pursuit of Earthly Paradise* (Paris, 1996)

Audiat, Louis, *Bernard Palissy: étude sur sa vie et ses travaux* (Paris, 1868)

Balsamo, Jean, 'Le prince et les arts en France au XVIe siècle', *Seizième siècle*, VII/1 (2011), pp. 307–32

Barbe, Françoise, et al., 'Bernard Palissy: nouveaux regards sur la céramique française aux XVIe et XVIIe siècles', *Technè*, 47 (2019)

Barry, Fabio, *Painting in Stone: Architecture and the Poetics of Marble from Antiquity to the Age of Enlightenment* (New Haven, CT, and London, 2020)

Bedos Rezak, Brigitte, *Anne de Montmorency: seigneur de la Renaissance* (Paris, 1990)

Beutler, Corinne, 'Un chapitre de la sensibilité collective: la littérature agricole en Europe continentale au XVIe siècle', *Annales*, XXVII/5 (1973), pp. 1280–301

Bienassis, Loïc, and Antonella Campanini, 'La reine à la fourchette et autres histoires. Ce que la table française emprunta à l'Italie: analyse critique d'un mythe', in *La table de la Renaissance: le mythe italien*, ed. Pascal Brioist and Florent Quellier (Tours, 2022), pp. 29–88

Bonnet, Jules, 'Disgrace de m. Et de m Me de Pons à La Cour de Ferrare 1544–1545', *Bulletin historique et littéraire de la société de l'histoire du protestantisme français*, XXIX/1 (1880), pp. 3–17

—, 'Une Mission d'Antoine de Pons à la Cour de France (1539)', *Bulletin historique et littéraire de la société de l'histoire du protestantisme français*, XXVI/1 (1877), pp. 4–14

Braun, Gabriel, 'Le mariage de Renée de France avec Hercule d'Esté: une inutile mésalliance. 28 juin 1528', *Histoire, économie et société*, VII/2 (1988), pp. 147–68

Brioist, Pascal, and Florent Quellier, eds, *La table de la Renaissance: le mythe italien* (Tours, 2022)

Brunon, Hervé, 'Grottes de la Renaissance en France: état de la question', presented at 'Les décors profanes de la Renaissance française. Nouvelles hypothèses', a symposium organized by the Centre d'Histoire de l'Art de la Renaissance, Paris-1 Panthéon-Sorbonne University, directed by Philippe Morel, 19 June 2004, https://halshs. archives-ouvertes.fr, accessed 8 July 2022

Capodieci, Luisa, *Medicaea Medaea: art, astres et pouvoir à la cour de Catherine de Médicis* (Geneva, 2011)

Coccia, Emanuele, *The Life of Plants: A Metaphysics of Mixture* (Medford, MA, 2018)

Crépin-Leblond, Thierry, *Anne de Montmorency – un homme de la Renaissance* (Paris, 2014)

—, *Le dressoir du prince: services d'apparat à la Renaissance*, exh. cat., Musée National de la Renaissance, Château d'Écouen (Paris, 1995)

—, et al., *Une orfèvrerie de terre: Bernard Palissy et la céramique de Saint-Porchaire* (Paris, 1997)

Crottet, Alexandre César, *Histoire des églises réformées de Pons, Gemozac, et Mortagne, en Saintonge, précédée d'une notice étendue sur l'établissement de la Réforme dans cette province, l'Aunis, et l'Angoumois* (Bordeaux, 1841)

Decrue, Francis, *Anne, Duc de Montmorency: Connétable et Pair de France, sous les rois Henri II, François II et Charles IX* (Paris, 1889)

Dion-Tenenbaum, Anne, and Audrey Gay-Mazuel, *Revivals: l'historicisme dans les arts décoratifs français au XIXe siècle* (Paris, 2020)

Ferdinand, Juliette, *Bernard Palissy: artisan des réformes entre art, science et foi* (Berlin and Boston, MA, 2019)

Fragonard, Marie-Madeleine, 'Les meubles de Palissy: biographie d'artiste, légende et mythes', *Albineana, Cahiers d'Aubigné*, IV/1 (1992), pp. 25–37

Frommel, S., G. Wolf and F. Bardati, eds, *Il mecenatismo di Caterina De' Medici: poesia, feste, musica, pittura, scultura, architettura* (Venice, 2008)

Gagliano, Monica, John C. Ryan and Patrícia Vieira, *The Language of Plants: Science, Philosophy, Literature* (Minneapolis, MN, 2017)

Gendron, Christian, 'Les imitateurs de Bernard Palissy au XIXe siècle', *Albineana, Cahiers d'Aubigné*, IV/1 (1992), pp. 201–6

Giglioni, Guido, 'Plantanimal Imagination: Life and Perception in Early Modern Discussions of Vegetative Power', in *Vegetative Powers: The Roots of Life in Ancient, Medieval and Early Modern Natural Philosophy*, ed. Fabrizio Baldassarri and Andreas Blank (New York, 2021), pp. 325–45

Greenhalgh, Paul, *Ceramic, Art and Civilization* (London, 2021)

Hirai, Hiro, 'Logoi Spermatikoi and the Concept of Seeds in the Mineralogy and Cosmogony of Paracelsus', *Revue d'histoire des sciences*, LXI/2 (2008), pp. 1–21

Kamil, Neil, *Fortress of the Soul: Violence, Metaphysics, and Material Life in the Huguenots' New World, 1517–1751* (Baltimore, MD, 2005)

Knecht, R. J., *Catherine de' Medici* (London, 1998)

Kociszewska, Ewa, 'Astrology and Empire: A Device for the Valois King of Poland', *Journal of the Warburg and Courtauld Institutes*, LXXIII/1 (2010), pp. 221–55

—, 'The Sun King in the Realm of Eternal Winter', *French Studies Bulletin*, XXX/113 (2009), pp. 78–82

—, 'War and Seduction in Cybele's Garden: Contextualizing the "Ballet des Polonais"', *Renaissance Quarterly*, LXV/3 (2012), pp. 809–63

—, 'Woven Bloodlines: The Valois Tapestries in the Trousseau of Christine de Lorraine, Grand Duchess of Tuscany', *Artibus et historiae*, XXXVII/73 (2016), pp. 1–30

Kris, Ernst, *Le style rustique: le moulage d'après nature chez Wenzel Jamnitzer et Bernard Palissy; suivi de Georg Hoefnagel et le naturalisme scientifique* (Paris, 2005)

Kristeller, Paul Oskar, 'The Modern System of the Arts: A Study in the History of Aesthetics', *Journal of the History of Ideas*, XII/4, pp. 496–527; XIII/1 (1951), pp. 17–46

Lamy, Jérôme, 'Lire la Bible, explorer la nature: Bernard Palissy et le geste experimental', *Revue d'histoire du protestantisme*, III/3–4 (2018), pp. 375–93

Le Roux, Nicolas, 'The Politics of Festivals at the Court of the Last Valois', in *Court Festivals of the European Renaissance*, ed. R. Mulryne and E. Goldring (London, 2002), pp. 101–17

Leonhard, Karin, 'Pictura's Fertile Field: Otto Marseus van Schrieck and the Genre of Sottobosco Painting', *Simiolus: Netherlands Quarterly for the History of Art*, XXXIV/2 (2009–10), pp. 95–118

Lindberg, David C., 'The Genesis of Kepler's Theory of Light: Light Metaphysics from Plotinus to Kepler', *Osiris*, II/1 (1986), pp. 4–42

Mirot, Léon, 'L'hôtel et les collections du Connétable de Montmorency', *Bibliothèque de l'École des chartes*, LXXIX/1 (1918), pp. 311–413

Morel, Philippe, *Les grotesques: les figures de l'imaginaire dans la peinture italienne de la fin de la Renaissance* (Paris, 1997)

—, *Les grottes maniéristes en Italie au XVIe siècle: théâtre et alchimie de la nature* (Paris, 1998)

Muratori, Cecilia, 'Between Machinery and Rationality: Two Opposing Views on Animals in the Renaissance – and their Common Origin', *Lo Sguardo Rivista Di Filosofia*, XVIII/2 (2015), pp. 11–22

Newman, William Royall, *Promethean Ambitions: Alchemy and the Quest to Perfect Nature* (Chicago, IL, 2004)

Oger, Danielle, *Un bestiaire fantastique: Avisseau et la faïence de Tours, 1840–1910* (Paris, 2002)

Pelletier, Monique, 'Cartes, portraits et figures en France pendant la Renaissance', in *Cartographie de la France et du monde de la Renaissance au Siècle des lumières* (Paris, 2014), pp. 9–29

Perrin, Isabelle, 'Les techniques céramiques de Bernard Palissy', doctoral thesis, Université Paris-Sorbonne, 1999

Plaziat, Jean-Claude, 'Bernard Palissy (1510–1590) and the French Geologists: A Critical Reappraisal Concerning the Founding Naturalist and his Rustic Ceramics', *Bulletin de la Société Géologique de France*, CLXXXII/3 (2011), pp. 255–67

Quellier, Florent, 'L'automne horticole du Moyen Age, permanences médiévales dans les traités de jardinage de la première modernité (1486–1652)', *Archéologie du Midi Médiéval*, XXIII/1 (2005), pp. 109–17

Quiviger, François, 'Bernard Palissy et la Nature en fête', in *La Cour en fête dans l'Europe des Valois*, ed. Oriane Beaufils and Luisa Capodieci (Tours, 2022), pp. 181–92

—, 'Plis, ombres, lumières et mouvements: l'art du pli et ses ramifications aux arts du dessin', in *Le Banquet. Manger, boire et parler ensemble (XIIe–XVIIe siècles)*, ed. Bruno Laurioux, Agostino Paravicini Bagliani and Eva Pibiri (Florence, 2018), pp. 287–98

Rees, Emma L. E., *The Vagina: A Literary and Cultural History*, 2nd (revd) edn (New York, 2014)

Rudwick, Martin J. S., *The Meaning of Fossils: Episodes in the History of Palaeontology* (Chicago, IL, 1985)

Skrbina, David, *Panpsychism in the West* (London, 2005)

Smith, Pamela H., *The Body of the Artisan: Art and Experience in the Scientific Revolution* (Chicago, IL, and London, 2004)

—, *From Lived Experience to the Written Word: Reconstructing Practical Knowledge in the Early Modern World* (Chicago, IL, 2022)

—, and Tonny Beentjes, 'Nature and Art, Making and Knowing: Reconstructing Sixteenth-Century Life-Casting Techniques', *Renaissance Quarterly*, LXIII/1 (2010), pp. 128–79

Strong, Roy, *Les fêtes de la Renaissance (1450–1650): art et pouvoir* (Arles, 1991)

Vignon, Charlotte, *The Robert Lehman Collection*, vol. XV: *Decorative Arts* (New York, 2012)

ACKNOWLEDGEMENTS

I am particularly grateful, for their assistance, advice, conversation, correspondence, facilitation, kindness, generosity and support, to Françoise Barbe, Richard Blum, Nicola Bonazzi, Luisa Capodieci, Alex Ciobanu, Emma Devlin, Marie-Madeleine Fragonard, Andrea Marie Frisch, Aurélie Gerbier, Guido Giglioni, Niranjan Goswami, Ewa Kociszewska, Sergius Kodera, Clare Lappin, Michael Leaman, Eckardt Marchand, Deborah Metherell, Laetitia Métraux and Bill Sherman; special thanks to Agata Paluch for all of the above and much more.

PHOTO ACKNOWLEDGEMENTS

The author and publishers wish to express their thanks to the sources listed below for illustrative material and/or permission to reproduce it. Some locations of artworks are also given below, in the interest of brevity.

Bibliothèque nationale de France, Paris: 13, 19, 41, 44, 45, 46, 52; Catharijne-convent Museum, Utrecht: 11; The Cleveland Museum of Art, Ohio: 28; Holyrood Palace, Edinburgh: 15; The J. Paul Getty Museum, Los Angeles, CA: 6; Louvre, Paris: 4, 9, 23, 27, 29 (deposited at Musée National de la Renaissance, Écouen), 30 (deposited at Musée National de la Renaissance, Écouen), 31, 32, 37, 38, 39, 40, 49, 51, 55; Metropolitan Museum of Art, New York: 3 (gift of J. Pierpont Morgan, 1917), 7 (purchase, The Isaacson-Draper Foundation Gift, 2007), 8 (gift of Julia A. Berwind, 1953), 21 (Robert Lehman Collection, 1975), 26 (gift of Julia A. Berwind, 1953), 34 (Robert Lehman Collection, 1975), 35 (Robert Lehman Collection, 1975), 54 (gift of Wallis Katz, in memory of Marshall Katz, and in celebration of the Museum's 150th anniversary, 2020), 57 (Rogers Fund, 1921); Musée cantonal des Beaux-Arts de Lausanne: 18; Musée des Arts Décoratifs, Paris: 56 (© VG Bild-Kunst, Bonn 2025); Musée National de la Renaissance, Écouen: 5, 42; Musée National du Château de Fontainebleau: 10; Museo del Bargello, Florence: 22; public domain: 12; photos François Quiviger: 2, 17, 24, 25, 33, 47; Royal Collection Trust: 20; Skokloster Castle, Sweden: 43; Uffizi, Florence: 16; Warburg Wellcome Collection, London: 1; Wikimedia Commons: 14 (Unidentified location/Public Domain), 53 (Coyau/CC BY-SA 3.0).

INDEX

Illustration numbers are indicated by *italics*

Alberti, Leon Battista 98, 108, 122, 125
Androuet du Cerceau, Jacques 107, 121, 124, 135
 Petites grotesques 57
Arcimboldo, Giuseppe 82
 Emperor Rudolph II as Vertumnus 43
Aristotle 76, 115
Avisseau, Charles-Jean 135–8
 basin with snakes, ferns and bark *54*

Balzac, Honoré de 134
Beaujoyeulx, Balthasar de 92–6, 98, 103, 125
 Le balet comique de la royne 45, 46
Beaulieu, Girard de 92, 125
Belon, Pierre 108, 144
Bréart, Léon 136
Bruno, Giordano 49, 103
Bussi Leclerc, Jean 53–4

Calvin, Jean 13, 15, 32, 33, 34, 48, 122, *11*
Cardano, Girolamo 108, 118, 144
cast from life 19–21, 24, 50, 54–8, 60, 62, 75, 82, 85–9, 102, 111, 122, 133
Cellini, Benvenuto 124

Chicago, Judith 140
Choisnin, François 85, 108, 144
Circe 92–3, 96, 105, 122–3
Clouet, François
 Catherine de' Medici 14
 Henry II (workshop of) *15*
Coccia, Emmanuele 146
Colonna, Francesco 108, 127, 129
 Discours du Songe de Poliphile 52
crayfish 58, 67, 72, 79, 120, 144, *31, 32, 51*
Creten, Johan 140
 'Odore di femmina' *56*
Cunt Art Movement 140

Debacq, Charles Alexandre, *Bernard Palissy Burning His Furniture 7*
Della Robbia, Luca 56, 60
 Virgin and Child 22
Descartes, René 116, 134
Dorat, Jean, Rock of the Muses *44*
dressers 47, *48*
Dubois, François, *St Bartholomew Massacre 18*

enamel 8, 12, 13, 16–24, 49–50, 54–7, 59, 61, 63, 65, 69, 75, 79, 85–7, 95, 131, 138
Este, Ercole d' 14, 48

Ficino, Marsilio 103, 115
Filleul de la Chesnaye, Nicolas 92
fish 66, 72, 79, 81, 110, 120–21
Fontana, Lucio 139
fossils 54, 82, 98, 110, 114, 118, 120, 126
frogs 21, 56, 58, 67, 72, 100, 120, 137–8, *27, 31, 32, 37, 38, 39, 49*

Gaffurius, Franchinus, Harmony of the Spheres *50*
Gauguin, Paul 139
Gautier, Théophile 138
Gelli, Giambattista 122–3
Giraldi, Lelio Gregorio 14
Grotte des Pins *10*
grottoes 8, 10, 25, 28, 30–32, 35–7, 39–40, 46–8, 50, 62–3, 72, 75, 77–91, 93–5, 102, 105–6, 108, 111, 114–15, 125, 129–30, 137, 139, 142

Hamelin, Philibert 27, 35
Henry II, king of France 24, 26, 30, 40, 45, *15*
Henry III, king of France 15, 24, 43, 47, 52, 53, 89, 90–91, 103, *20*

Jamnitzer, Wenzel 58
rustic basin *23*

Kandinsky, Wassily 139
Kimiyo, Mishima 142

Land Art 140
Latour, Bruno 134
Leonardo da Vinci 10, 28, 59, 87, 124
Léry, Jean de 76
L'Estoile, Pierre de 53, 92, 113

Levine, Marilyn 142
Limosin, Léonard 57
Anne de Montmorency *9*
lizards 19, 21, 56, 72, 75, 85–6, 90, 95, 98, 129, 134, 137, 144, *37, 38, 39, 49*
Louis XII, king of France 14
Louis, Morris 139
Luther, Martin 32, 34, 122

Machiavelli, Niccolo 122–3
maiolica 16, 29, 55–7, 81, 98, *21*
Marot, Clément 15
medals 23, 47, 6, 126, *17*
Medici, Catherine de' 11, 14, 15, 24–5, 30, 40–47, 56, 62, 65, 77, 89–90, 101, 107, 113, 124–7, 138, *14*
Michelangelo 28, 144
Michelet, Jules 134
minerals 7, 18, 24, 38, 54, 57, 59, 65, 69, 76, 81, 83, 86, 98, 108–12, 114, 120, 124, 126–7, 129, 142
Miró, Joan 139
Montaigne, Michel de 123
Montmorency, Anne de 11, 14, 24–30, 32, 35–7, 40, 46–7, 56, 63, 77, 89, 100, 107, *9*

Neoplatonism 69, 85, 102–3, 105–6, 108, 115
Newman, Barnett 139
Nicola da Urbino, armorial plate *21*

oysters 72, 112, 121, 130

Palissy, Bernard
Architecture et ordonnance de la grotte rustique 12
bronze of *53*

cast for architectural term *42*
cast of basin *5*
cast of lizard *4*
Discours admirables *19*
dish by follower *8*
ewer with frogs and crayfish *31,*
 32, 51
ewer with shells *29, 30, 33, 47*
fragments *2*
fragments of medals *17, 24, 25*
grotto fragment *40*
oval basin (attributed to) *6*
pilgrim flask *34, 35*
portrait of *1*
Recepte veritable *13*
rustic basin *27, 37, 38, 39, 49*
rustic plate by follower *26*
sauce boat by follower *28*
Panpsychism 114–15, 122, 144
Paracelsus 108, 111, 115, 134, 144
Parthenay, Anne de 14, 32, 34–5, 48
Patin, Jacques 92
Patrizi, Francesco 115
petrification 54, 65, 110, 118
Philibert de l'Orme 31, 107, 124,
 127, 135
Picasso, Pablo 139
plants *7,* 19, 21, 24, *38,* 100, 105, 109,
 111, 114–17, 129–31, 144, 146
Pollock, Jackson 139
Pons, Antoine de 13–16, 24–5, 32,
 34–5, 48, 55
Postel, Guillaume 85, 108,
Primaticcio, Francesco 28, 30, 69,
 124, *10*

Renée de France 14, 34, 48
Robert, Arthur Henry, *Cabinet du*
 Docteur Sauvageot 55
Rosseli, Cosimo 98

Rosso Fiorentino 29
Rothko, Mark 139

Saint-Porchaire enamel 17, 30, 100,
 136, *3*
Saintes 12, 16–17, 25, 27, 29, 32,
 35–7, 45, 47, 59, 60–61, 62, 77,
 123, 143
salt 13, 19, 50, 106, 109, 111, 112–14,
 126
Sambin, Hugues 81
 Oeuvre de la diversité des termes 41
Sauvageot, Charles 136, 138, *55*
Schriek, Otto von 134
Sedan 12, 47–8, 50, 59, 61, 90, 143
Serlio, Sebastiano 30, 107, 121, 124
Shaw, Richard 142
shells 19, 20, 21, 24, 29, 62–3, 66–7,
 69, 72, 90, 98, 101, 110, 112,
 121, 130, 142, 144, *29, 30, 33, 47*
snakes 19, 58, 62–3, 72, 75–6, 85,
 90, 98, 129, 137–8, 144, *27, 34,*
 35, 37, 38, 39
soil *7, 38,* 85, 109, 112, 130–31

trees 29, 83–6, 90, 95, 110, 115–17,
 130–51, 144
Turrell, James 140

Vasari, Giorgio 43, 98, 125–6
Vecellio, Cesare, *Henry III 20*
Vitruvius 84, 121, *36*
vulva 101, 140

water 30, 44, 50, 54, 58, 63, 65–7,
 69–70, 72, 76, 79, 81, 86,
 90–91, 93, 96, 101, 106,
 109–12, 119, 131, 138, 140,
 142, 144
Water Festival at Bayonne 16